WILD WOMEN of WASHINGTON, D.C.

WILD WOMEN of WASHINGTON, D.C.

A HISTORY OF DISORDERLY
CONDUCT FROM THE LADIES
OF THE DISTRICT

CANDEN SCHWANTES

THE
History
PRESS

Published by The History Press
Charleston, SC 29403
www.historypress.net

First published 2014

Manufactured in the United States

ISBN 978.1.62619.367.3

Library of Congress CIP data applied for.

CONTENTS

Dedication 7

Preface 9

Introduction 11

1. Flirtatious First Ladies 13

2. Mary, Mary, Quite Contrary 31

3. Rebellious Belles 45

4. Pioneers in Petticoats 55

5. Duplicitous Dames 79

6. Scandalous Socialites 91

7. Dallying Dolls 101

Bibliography 119

About the Author 125

DEDICATION

While trying to write this book, the government shut down, I broke my foot and my hard drive crashed. If it was not for the support of my fiancé, my family and my coworkers, this book would not have happened and I might have had a mental breakdown. To everyone at DC by Foot who covered my tours so I could write; to my parents, who read the book in its first draft; to my mom in particular, who helped keep in mind that not everyone reads the way I think; to all at The History Press for their flexibility and encouragement; and to Manny for…well, everything; thank you!

PREFACE

My dad always taught me that history is lies agreed upon. Everything I write in this book could be a lie; I don't know—I wasn't there! And to be honest, a lot of it is based on hearsay, gossip and diary entries of women scorned. Wherever possible, I try to be as unbiased for or against someone's actions. I've reported what I've found, but when it comes to what is written down, it's not always what actually happened.

The idea for this book was to be part of The History Press's "Wicked" series, but then we decided that *wicked* was not the right word. It has a negative connotation, and many of these women were anything but negative. Sure, there were some affairs, some thievery and prostitution, but for the most part, what makes these women "wild" is that they went against the social norms and common perceptions of what was appropriate for a lady of the times. By today's standards, it is commonplace for a woman to do...well, anything! But this book isn't about today.

Consider this a summary. The remarkable women included in this book deserve and often have lengthy tomes written about them, in-depth looks into their lives, thoughts and actions. This is not one of those books. It is a highlight of their unconventional—and sometimes scandalous—ways. It does not include everything, nor does it give a full picture of each woman. Listed in the bibliography are biographies of many of these ladies for a more comprehensive view.

INTRODUCTION

W e luckily live in a time when anything you can do, I can do better. Women of the twenty-first century can wear the pants and bring home the bacon, both figuratively and literally. There was, though, a time in which a woman in pants caused a stir and the only bacon brought home

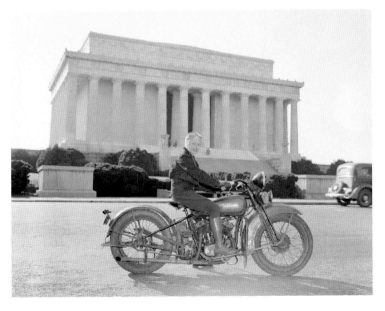

Sally Halterman, the first female to get a motorcycle license in Washington, D.C. (1936). *Library of Congress Prints and Photographs Collection.*

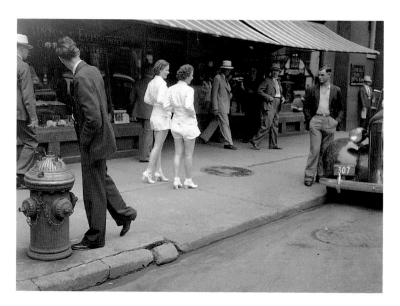

Women in shorts being stared at by men outside Stainton and Evis Furniture store. *City of Toronto Archives Fonds 1257, Series 1057, Item 4765.*

came from the butcher. Throughout the years, however, women proved they were not the weaker sex.

Women of American history, specifically in Washington, D.C., were both held to higher standards and expected to be progressive. It was a conundrum unique to the women of the men who led the country. Access to the political machine in a city literally built by revolutionaries encouraged and inspired some feminine rebellions. And yet if you were an elite woman in the city, all eyes were on you to set the example of etiquette, fashion and culture.

No womanly position was held more aloft in the eyes of social climbers than that of first lady. It was a stressful position where, then and now, your personal life was never actually personal. Few were able to keep their secrets, and some of these women proved to be unconventional.

While the brothers went off to the battles, their sisters stayed at home and used their womanly ways to aid the cause. When these flirtations were not enough, the women just did the fighting themselves. From soldiers to lawyers, women in the nineteenth century led the way into professions normally reserved for men. And they often did it in skirts and heels with all eyes on them.

Women in Washington had affairs, held jobs, spied on neighbors and stood up to say that they were equal. What brings these wild women together is that they didn't do what they were told—in fact, they did just the opposite.

CHAPTER 1
FLIRTATIOUS FIRST LADIES

T here are two ways to look at the fact that scandal and the White House seem to go hand in hand. On the one hand, presidents and would-be presidents have their every step followed and every mistake aired and recorded for posterity. Or perhaps the American voting population has a penchant for electing philanderers.

Of our past presidents, it is often said that only one is believed *not* to have had an affair before, during or after his presidency. That was Ronald Reagan, the first divorced man ever elected to the office. Of course, we don't actually know if this is true, since these types of misdeeds happen behind closed doors.

And while White House gossip most often brings to mind the president, there is another side to the story: that of his wife.

RACHEL JACKSON HAD TWO HUSBANDS

Rachel Jackson from all accounts seems like a lovely lady who made a mistake—or rather, two. The first was marrying her husband, and the second was not making sure the divorce was final before marrying her next.

If it weren't for the political ambitions of her second husband, this would have likely never come to light. It would have had little consequence to the grand scheme of the couple's life together. But she happened to fall in love with Andrew Jackson.

This was before he was anything more than a small-town lawyer in Tennessee. When he arrived in Nashville, Jackson took up residence as a boarder with the widow Donelson. It was here that he met Rachel Donelson Robards, the widow's lovely but married daughter.

At the age of eighteen, Rachel had married twenty-seven-year-old Lewis Robards in Kentucky. From here, whether Rachel was a battered woman or adulterer depends on whose story you believe.

According to Lew Robards, after living in his mother's home with Rachel for three years, Robards could take no more of her shameless flirting with other men. Claiming she was unfit as a wife, Robards asked his brother-in-law to take Rachel back home. After some time apart, seeking reconciliation, Robards came to his wife's Nashville home only to find her in close comfort with Andrew Jackson. Before anything could be done, Rachel and Jackson left for Natchez, Mississippi, where they were wed. Heartbroken, Robards filed for divorce on the grounds of abandonment and adultery in the courts of Tennessee in 1794, three years after her marriage to Jackson.

However, according to the Jacksons, after living in her mother-in-law's home for three years, Rachel could take no more of her husband's physical and mental abuse. His intense jealousy only increased when they returned to Nashville after the death of her father. Abandoning Rachel, he returned to Kentucky. But after some time apart, Robards came home only to accuse her of shamelessly flirting with another man, Andrew Jackson. Rachel and Jackson's relationship was innocent; though there were feelings, the only action they led to was Jackson's attempt to protect her. Before Robards could do anything, Jackson escorted Rachel, chaperoned by another couple, to Natchez for her safety. Jackson later heard that Robards had filed and was granted a divorce, leaving Rachel free to marry. The two were wed in 1791 and lived with Jackson's mother in Nashville for three years. All was bliss until they found out that Robards had either never filed for divorce or that it was never finalized in the courts. Rachel and Andrew Jackson had been living in sin for three years. When the legal papers were finally drawn up ending her first marriage, Rachel and Jackson remarried in Tennessee.

An honest mistake or a tale of bigamy? All accounts point to the piety and kind-heartedness of Rachel Jackson, traits that do not seem to describe an overly flirtatious woman. A good friend of the Jacksons, Colonel Thomas Benton, once wrote down his thoughts on Mrs. Jackson:

A more exemplary women in all the relations of life—wife, friend, neighbor, relations, mistress of slaves—never lived, and never presented a

more quiet, cheerful, and admirable management of her household. She had the general's own warm heart, frank manners, and admirable temper; and no two persons could have been better suited to each other, lived more happily together, or made a house more attractive to visitors.

If one wanted to look into the technicalities, though the incident was labeled as bigamy, it was never legally true. Rachel had a legal marriage in the court of Kentucky to Lewis Robards, but it was not until after their divorce that she ever had a legal marriage to Andrew Jackson. In Mississippi, where they were first wed, only Catholic marriages were recognized, and Rachel and Jackson were Protestant. This, however, was too nuanced an excuse to really work as justification at the time.

As Andrew Jackson's fortunes and popularity rose, those against him used Rachel as a way to stain his character. Anti-Jackson newspapers chose to focus on the actions of his wife, with support from rival candidate John Quincy Adams. Adams supporter Charles Hammond, a Cincinnati editor, published a pamphlet called *Truth's Advocate and Monthly Anti-Jackson Expositor*, stating that the American public has a "deep stake in knowing the character of his wife, and if she be a weak and vulgar women, his pretensions should be passed by…[as] it touches on the character and qualifications of the husband." Hammond's detailed description of the affair and testimonials from those present asked, "Ought a convicted adulteress and her paramour husband be placed in the highest offices of the free and Christian land?" On the campaign trail, Adams's supporters would stand outside Jackson's hotel room with signs that read, "The ABC of Democracy. The Adulteress, the Bully, and the Cuckold."

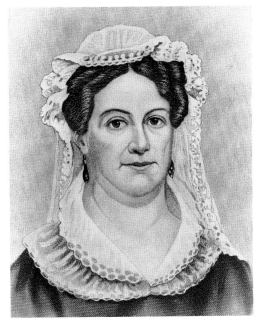

Rachel Robards Jackson, beloved wife of Andrew Jackson. *Library of Congress Prints and Photographs Collection.*

Rachel's mild-mannered soul could not take the

slander. When she died of a heart attack shortly before moving to the White House, Jackson blamed his opponents' attacks for literally breaking her heart. He never forgave them, and his love of Rachel would later have him stand up for another woman attacked in the press.

In an era that modern women like to remember as a time of the chivalrous nature of gentlemen, the election of 1828 used Rachel as the fodder for scandalous gossip against candidate Jackson. It was one of the first times that such a personal event of a potential president was used against him in the election. Prior to this, the actions and previous life of candidates' wives were of little consequence, but since Rachel Jackson, we not only vote on whom we want as a president but also as a first lady.

THE ROSE OF LONG ISLAND

Rachel Jackson wasn't the only first lady whose childhood mistakes were used against her in later political years. For Julia Tyler, however, her husband was already president when they met, so all they caused were gossip.

As a teenager growing up in the high-class society of New York, Julia Gardner agreed to the use of her image in an ad for a New York clothing exchange store. Standing next to an older man with a top hat, coat and cane, she carries a sign that says, "I'll purchase at Bogert and Mecalmly, no 86 9th Avenue, their goods are beautiful and astonishingly cheap." The caption of the image said, "Rose of Long Island."

This proved to be an unacceptable decision. Appearing in advertisements was not something done by women of her upbringing. This would be the first known commercial endorsement from a prominent woman in the history of New York. To avoid more scandal, her parents sent her to Europe. On the way there, Julia was said to become involved with a gentleman on the steamship, then a German nobleman, a Belgian count and a London War Ministry employee. So much for avoiding gossip.

The advertisement might have been a prediction of her future life. Letitia Tyler, wife of President John Tyler, died clutching a rose while serving as first lady. It was believed this was a sign that John's next wife would be named Rose—or perhaps nicknamed the Rose of Long Island.

The Gardners spent the social season in Washington, D.C., where they were part of the inner circle of presidential acquaintances. Despite it only being five months since Letitia had died, President Tyler was obviously

attracted to young Julia and proposed marriage. He was thirty years her senior, a recent widow and president of the United States, so her first response was "No, no, no" but obviously not in a way that would deter him from trying again. He continued to pursue her, and she continued to allow it.

It was a tragedy that finally led her to consent. On an outing with the president and other government officials on the frigate *Princeton*, a demonstration of a naval gun called the Peacemaker went awry, killing many on board, including Julia's beloved father. Perhaps it was the close call to her own life or the need for a paternal figure, but shortly after, Julia and President Tyler were married in a secret ceremony in New York.

There were only twelve guests at the wedding, and only one of Tyler's eight children from his previous marriage was in attendance. The rest of his children were unaware of the nuptials, though all but his daughter Letitia eventually accepted the marriage. Letitia never approved of Julia; she was, after all, nearly the same age as her new stepdaughter, and in fact, three of John's children were older than Julia.

While the public was keenly interested in the marriage and the couple's age difference, Julia and President Tyler were happily married for eighteen years and had seven children. That's in addition to his previous eight, making John Tyler the most prolific first father. Since the anti-Catholic riots were occurring around the time of their wedding, public opinion also noted with some disdain that Julia was Catholic, but this neither deterred her from her faith nor had much effect on the public's admiration of her.

Julia was only in the White House for eight months, but she expanded on her earlier newspaper appearances, becoming the first first lady to solicit and encourage coverage. For her brief time in the White House, she ensured that she would be remembered, though the more conservative press often criticized her for lavish parties and the amount of champagne served at them.

She was instantly recognizable, thanks to her efforts in publishing an engraving of herself labeled "The President's Bride." If you did not own the engraving, you could at least imagine her beauty and grace as described by her good friend, a journalist. Washington correspondent for the *New York Herald* F.W. Thomas spent his articles detailing her clothes and demeanor at official events rather than the events themselves. By befriending the man who would write about her, Julia likely had some say in what was written. In a sense, she was her own publicist. A photograph of Julia was also taken, the first to be taken of a sitting first lady, but it was never sold to the public and was lost until it was published for the first time in 1990.

When New York composer Lovel Purdy asked for permission to name a new polka after her, she agreed to the name "The Julia Waltzes" as long as it would also be stated that the song was, indeed, named after her. Sure enough, on the sheet music cover, the words "Mrs. Tyler" are larger than the name of the composer or the piece. At White House events, the young first lady did something no others had done before her, or at least none had been recorded doing: she danced. In public. Dancing in the White House was something that would be forbidden a few months later by her successor, Sarah Polk.

Julia changed the social scene in the White House to fit the standards of the European ways that she had learned years earlier on her travels. Whereas Tyler used to stand in the middle of the room to address his constituents, Julia moved him off to the side against the wall, both for efficiency and his safety. Regardless of the practical reasoning, it did bring about the comparison to royal greetings. Just in case one was not sure who was the president among the crowd, legend credits Julia with having the marine band strike up the tune that we now call "Hail to the Chief" as he entered the room. Not to be outdone by other wives, Julia brought the royal tradition of "ladies-in-waiting" to the White House court. She often traveled with an entourage of a dozen young women dressed all in white, nicknamed the "vestal virgins."

Julia's luxurious lifestyle was not funded by federally appropriated monies but rather by the family's wealth, which would end up nearly bankrupting Tyler. Making it clear that the public was not paying for her extravagances would be essential, because extravagances might be an understatement. She had the U.S. consul in Naples, Italy, procure her a rare breed of Italian greyhound. Named Le Beau, the dog was brought to the States to "grace the White House lawn" and escort Mrs. Tyler on walks in the city. Should she not be walking through the town, she could travel on her coach drawn by eight white Arabian horses. The young Julia only had eight months to be first lady, since Tyler had no intention of running again. "Again" might not be the right term. "His Ascendency" actually ran as vice president to William Henry Harrison under the campaign slogan "Tippecanoe and Tyler, Too," but shortly after the inauguration, Harrison unexpectedly died. Mrs. Tyler, the Rose of Long Island, made good use of those eight months in the White House.

Her Highness Martha

Julia Tyler was not the first, nor the last, woman in the White House to be accused of queenly ways. By a public that was intimately aware of royalty, Martha Washington was reproached for bringing too much of what Americans had just fought against into the presidency.

Martha's own desire was not to be the lady of the nation, but she considered it her duty as a wife. One of these responsibilities was as hostess. Her lavish parties and dinners were critiqued as reminiscent of the British monarchy. But Martha knew that in order to compete as a new nation, the president had to meet these European standards. Her Friday evening dinners were invitation only and followed the French model. Guests were announced and brought into her presence before being seated. Once all guests had been introduced, they moved into a second room for an event akin to the British "high tea." There were no card games, no storytelling and absolutely no flirting. Martha hoped the imitation of these European ways would make her non-American guests more comfortable and that they would in turn regard the president, and thus his country, not as backwoods bumpkins but worthy of their attention. The imitation of European ways was something that First Lady Edith Wilson would also do more than a century later when she appeared in Europe among British, Belgian and Italian royalty at the end of World War I, in one of the first instances in which the European media paid attention to an American president.

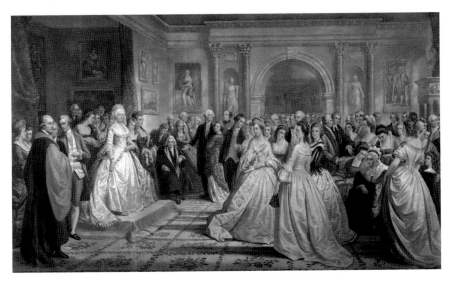

One of Lady Washington's receptions, which led to criticism that Martha Washington was too "royal." *Library of Congress Prints and Photographs Collection.*

Any woman held in such a lofty position would have critics. Despite this criticism, Martha was regarded as an all-American woman. Aside from the assessment of being too European in her soirées, Martha was one of few women of means who did not embrace European fashion. She did not follow the trends but rather continued her preference for homespun muslin dresses. Abigail Adams, wife of the vice president, referred to Martha admiringly as "plain in her dress, but that plainness is the best of article." With all the records discussing her plain dress, the only complete item to survive from her wardrobe is a silk satin gown. Martha wrote in a letter to her niece hinting at the dissatisfaction of her new requirements in the pubic eye, stating, "My hair is set and dressed—and I have put on white muslin habits for the summer—you would I fear think me a good deal in the fashion if you could but see me."

As it is today, you can never please everyone. Her personal preference to avoid ostentation was ignored to provide an air of formality, and yet she was criticized for being regal.

ELEANOR ROOSEVELT NÉE ROOSEVELT

When Eleanor Roosevelt married Franklin D. Roosevelt, she had no need to go through the arduous process of changing her name. She was born Anna Eleanor Roosevelt, niece to Teddy Roosevelt and a distant cousin to Franklin, whom she married despite his mother's disapproval. This was not so rare; President Martin Van Buren married his second cousin, Hannah.

Eleanor is one of the most highly regarded first ladies, which has more to do with her own works than her twelve years as the president's wife. Her association with the United Nations and Presidential Commission on the Status of Women, as well as her rare public stance on racial issues, is to be honored.

Her political efforts required time and passion—neither of which she needed to provide to her husband. Her daughter claimed that Eleanor considered sex to be an "ordeal to be bourne." But that might have to do with living with FDR, not necessarily because of his paralysis but more due to his moral misgivings.

In 1918, after thirteen years of marriage and six children, she discovered love letters between FDR and his mistress, Lucy Mercer. Though FDR might have wished to secure a divorce, threats from his mother to disinherit him found him

apologizing to Eleanor. They did not divorce, but their marriage was from then on a political union rather than one of love.

FDR continued to be associated with Lucy Mercer for years after— in fact, until his death. However, Eleanor is also rumored to have found love in other places. This was not a sexual, passionate kind of love but rather a comforting, emotional connection with another man and another woman.

Earl Miller was a former New York State police sergeant, navy middleweight boxing champ and 1920 Olympian. This made him well suited to the position of bodyguard. A handsome man with a parentless childhood in common, this made him well suited for friendship with Eleanor. In 1929, when she was forty-four and he thirty-two, Miller

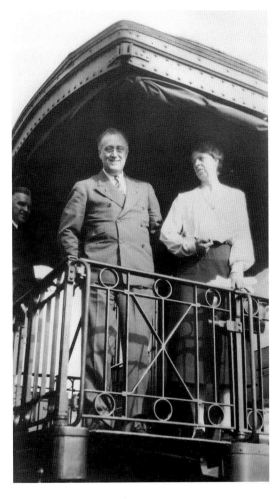

Earl Miller standing behind FDR and Eleanor. *Franklin D. Roosevelt Presidential Library Archives.*

was assigned to protect Eleanor when she was the wife of the governor of New York. This was years after she discovered FDR's infidelity, and in Miller she found a friend, and maybe more. The two were often seen holding hands and arm in arm. Miller continued to deny that there was ever an affair, but even her children acknowledged what he provided for her, at least emotionally.

Miller taught her to drive, play tennis, ride a horse and shoot a gun. He would stand behind photographers making faces at Eleanor to get her to smile for the camera. In all, he made her feel comfortable with herself and in public in front of the camera. Their relationship may have been romantic,

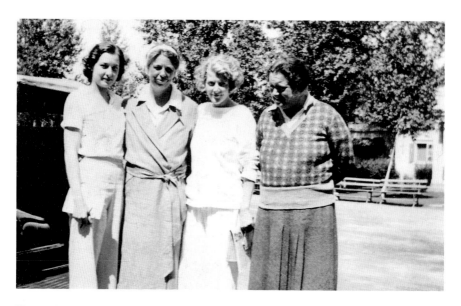

Eleanor Roosevelt (second from left) and her close friend Lorena Hickok (far right). *Franklin D. Roosevelt Presidential Library Archives.*

if not physical. No proof of an affair exists, and the historical records can only hint at it.

To quell the gossip of an improper relationship with Eleanor, Miller married twice. He later says that the marriages were to women he did not love in hopes of stopping the rumors. It didn't work. His third wife divorced him in 1947 and stated there were letters that proved a relationship between the two friends. The judge had the letters sealed.

The relationship could have been nothing more than a deep friendship. Miller might not have been Eleanor's type. By record, another close friend of Eleanor's was reporter Lorena Hickok. By rumor, "Hick," as Eleanor called her, was her lover.

Again, proof is hard to come by and facts can often be misinterpreted. Numerous letters between the two are kept in the FDR Archives. In one, Eleanor writes, "Hick darling, All day I've thought of you and another birthday I will be with you. Tonight you sounded so far away and formal. Oh, I want to put my arms around you. I ache to hold you close. Your ring is a great comfort. I look at it and think, 'She does love me,' or I wouldn't be wearing it." The ring was a sapphire gift from Lorena that Eleanor wore to FDR's inauguration.

Many friends and family members say that Eleanor was an intense writer and her letters were always full of emotion. She shared a deep relationship

with and love for Lorena, but that is not to say definitively that they were lovers. However, some of the letters seem to suggest otherwise. Lorena writes to Eleanor, "I've been trying today to bring back your face…Most clearly I remember your eyes and the feeling of that soft spot just northeast of the corner of your mouth against my lips."

Lorena was an accomplished reporter. By 1932, she was the most well-known female reporter with the Associated Press and was assigned to the presidential campaign of FDR. For the next three decades, the two women were nearly inseparable. There are more than three thousand letters between the two, not including the ones that were destroyed. Eleanor wrote ten- to fifteen-page letters daily to Lorena. Some would make a schoolgirl blush, and others discussed mundane facts of life, like Lorena's effort to drink less corn liquor. Just like Earl Miller, Lorena contributed to Eleanor's life in ways that the American public would remember. Lorena felt her relationship with the first lady affected her ability to remain unbiased, so she left the Associated Press and worked for the government. It was with her assistance that Eleanor began to work toward the involvement of women in politics. She started an all-women press conference for female reporters that didn't just talk about White House events and first lady fashion. Earl helped her speak in public with confidence, and Lorena inspired her efforts to include women in political affairs.

Lorena Hickok was a known lesbian. She was stout and heavy, smoked cigars and often used coarse language. And she deeply loved Eleanor. This is without question. Unconditional love was something to which Eleanor was not accustomed, whether from her parents, husband or children. Later reports from her children say that Eleanor's overly attached letters are attributed to her attempts to hold on to that connection.

Eleanor's granddaughter replies to the stories of a lesbian affair with a modern view, saying, "I have no idea whether Lorena Hickok had a homosexual relationship with my grandmother or not. And my feeling about that is kind of: Who cares? They were very good friends. And if they could make each other happy in any way, then that's what's important."

A Modern First Lady

Florence Kling Harding's first legal marriage was to future president Warren G. Harding, but this wasn't the first man she lived with or the first man with whom she had children.

At the age of nineteen, she ran off with Henry Atherton De Wolfe. Henry was a childhood friend from a troubled family and a couple years older than Florence. Family legend says they eloped to Columbus, Ohio, but there are no records of marriage there or where the couple lived. In the late 1800s, Ohio law only required a couple to "hold themselves" as married to meet the requirements of a common-law marriage.

Still, when they had their son, Eugene, he was born out of wedlock. Henry was a drunkard and not very successful, but in his defense, he was a father at twenty-one with no support from the family he had run away from. When their son was only two, De Wolfe abandoned the baby and Florence. He died at the early age of thirty-five.

Reports differ on which angle to take regarding Florence's father and the way he raised her. He either supported her self-reliance or ordered her to be raised as the boy he had wanted, forcing her to be self-reliant. Her father had not supported the illicit union with De Wolfe, and when she returned home a single mother, she found an apartment on her own. Some say she refused to live at home and others that her father refused to have her back. In support of her can-do attitude, Florence once said, "No man, father, brother, lover or husband can ruin my life."

Despite not being legally married, Florence filed for divorce from her common-law husband in 1886 in Reno. It was common back then to go to Nevada to obtain a quick divorce, where as now one goes there for a quick marriage. She returned to the use of her maiden name. To support herself and her son, she taught piano. A job was nothing new to her. She had been working since she was a young girl in her father's hardware store, just as a son would have done from an early age.

Florence later married the brother of one of her students, successful newspaperman Warren G. Harding, against her father's objections. Florence's father wasn't all bad, and he became legal guardian and raised his grandson, Eugene. As a couple, the Hardings had no children of their own, but on occasion, Eugene would stay with them when things weren't going well with his strong-willed grandfather.

As Harding's political career grew, Florence made her husband her hobby and supported him as he was elected president in 1920. Unlike previous first ladies, Florence Harding was considered a modern woman. She did not hide her intelligence and actively shared her political opinions. Her husband always addressed her as "Duchess." She was active in the rights of women, not just to vote but also in support of female federal workers, and encouraged the education and physical exercise of girls. She opened the

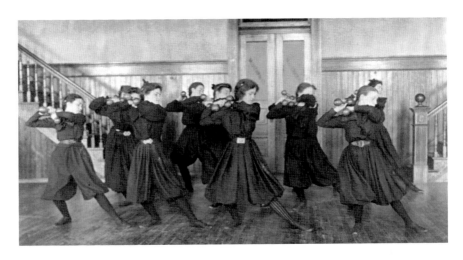

Female students at Western High exercising with dumbbells. Though this photograph was taken before her time, physical exercise by young women was encouraged by Florence during her time as first lady. *Library of Congress Prints and Photographs Collection.*

White House to the public, including divorced women who were previously not invited to social events.

The social custom was that the first lady was simply a hostess, involved in the social functions of the president. As the twentieth century progressed, this role was moved to the back burner. Florence was active in the causes she cared about, and more importantly, she allowed the American public to see her. She didn't really enforce the unspoken rule that the first lady should not be directly quoted. Rather than posing for formal pictures, she would arrange for cameramen to capture candid moments with her and guests to the White House, sometimes even operating the video camera herself.

Like those before her, the religious right criticized her. The "sinful syncopation" of jazz music in the White House garden and the Hardings' participation in the dances that accompanied this new style of music led certain newspapers to condemn her actions. And like her immediate predecessors, the enforcement of Prohibition was not necessarily upheld within the confines of the White House. With Florence acting as bartender herself, the Hardings' parties would somehow have a supply of liquor.

Harding's relationship with his wife may have been politically sound thanks to her support of him and the public's support of her. However, romantically, he wandered. The extent of his affairs is difficult to surmise. After his death, Florence destroyed many of his personal papers to keep his reputation untarnished.

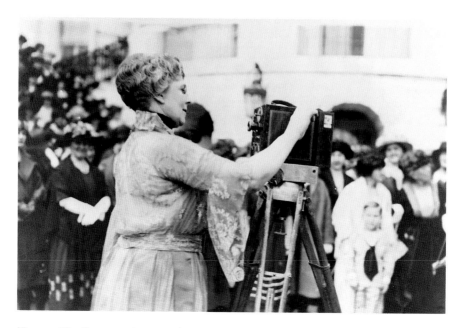

Florence Harding operating a movie camera on the White House lawn. *Library of Congress Prints and Photographs Collection.*

Though Harding died while in office, his death may not have been unexpected at all. Encouraged by her friend Evalyn Walsh McLean's belief in astrology, Florence had put stake in a prediction she received prior to the Hardings' time in the White House. The psychic stated that if Harding continued his election campaign, he would win but would die from poison before his term was through.

Harding visibly deteriorated during their trip down the West Coast. He slipped up verbally in his speeches and physically on his walks. Despite the presence of a naval physician, Joel Boone, the only medical professional to have complete access to the president was Florence's friend Dr. Charles Sawyer. A dear friend to Florence after he helped bring her back to health after kidney failure, "Doc" Sawyer was the only person she allowed to personally take care of Harding. Even when Dr. Boone was there with the patient, he was not without Doc's eye over his shoulder. Yet it wasn't Doc who noticed the president's enlarged heart and weakened state as the days wore on.

Rumors began that Florence had poisoned her husband on the trip. The motives vary from jealousy from his many affairs to a mercy killing to save him the embarrassment from ongoing political scandals. Evalyn, one of

Florence's closest confidantes, suggested it may have been a self-fulfilling prophecy—not to say that Florence poisoned her husband, but rather that she simply did not acknowledge his failing health. Just as her astrologer predicted, she was powerless to stop his deterioration.

We do not know what killed President Harding. Florence refused to allow an autopsy. A local undertaker was preparing him for burial within minutes of his death. The official report stated that the president died of a stroke, and while the physicians signed this report, they never actually conducted any sort of postmortem.

Florence Harding was a progressive first lady in many ways. She did not shy away from the public eye or consider her role as merely that of a hostess. Yet there is much we do not know about her, including whether she was ever legally married to the father of her son, what influence her intelligence had on her husband's politics and whether she got away with murder.

The First First Lady

Dolley Madison was the nation's preeminent, longest-serving and perhaps *first* first lady. "Dolly Madison" is a bakery that makes Hostess cakes. Though birth records spell her name Dollie, the historic woman spelled her name Dolly more often than not. Spelling in the eighteenth century was often varied and interchangeable, so for the sake of clarity—not that she could easily be confused with a snack cake—historians today refer to her as Dolley.

She was not at first the wife of a president, but she took her role to a different level than the others. Martha Washington was a reluctant hostess, performing the duties out of obligation rather than desire, and Abigail Adams spent only eighteen months of the presidency in the capital and even then was more known for her politics as "Mrs. President."

When Thomas Jefferson became president, he was a widow with no wife to serve as first lady. This is how Dolley Madison came to begin her service as first lady.

Dolley was widowed with a young son when she met James Madison. She was an outgoing beauty in the capital of Philadelphia and was courted by many men. Though he was seemingly her opposite—quiet, reserved and a bachelor at forty-three—James and Dolley were engaged a few months after meeting. Dolley was raised in the Quaker faith. When she married Madison outside the faith, she was expelled from the church. This would eventually

give her the freedom to start her trademark fashion of vibrant colors and turbans, far from the drab gray of the Quaker garb.

James Madison was asked by his friend newly elected President Jefferson to serve as secretary of state, bringing the Madisons to Washington. In fact, for the first year, the Madisons lived with Jefferson in the White House. Here Dolley took on the task of co-hosting White House events for which a women's touch was deemed necessary. She was a skilled hostess and became popular among the social elite in the city. Dolley even helped the fundraising efforts to support the Lewis and Clark expedition out west to explore the Louisiana Territory, the route of which actually included none of what we now know as Louisiana. Jefferson was more politics than party and did not often host events. The social scene was centered at Dolley's own house down the street.

If it was not for Dolley's social prowess, her husband may not have won the 1808 election. The other party tried to lessen her popularity and claimed that she had had an affair with Jefferson. The government largely ignored this, however. Both Jefferson and the Madisons decided not to dignify this with a response, but the rumors continued and grew. From having an affair with Jefferson, it snowballed into reports that he had pimped Dolley and her sister, Anna, to foreign dignitaries visiting the White House. The press joined in the discussion but, as was standard for the time, did not come right out and report the rumors. The *Federal Republican* in Georgetown ran an advertisement for a pretend work. It was said to be a collection of writings on moral and political law and included as an example a political couple: an impotent husband and his adulterous wife. With the time and the rumors both of Dolley's affair and Madison's impotency, this was an obvious jab at the couple. It was one of the few times that Dolley responded to any accusations.

Despite the efforts of the Anti-Federalist Party, James Madison won the election. His opponent, Charles Pinckney, said of his defeat, "I was beaten by Mr. and Mrs. Madison. I might have had a better chance had I faced Mr. Madison alone." Dolley was not officially the president's hostess until 1809, but by then she had eight years of practice behind her. She took over the household and had the building newly plastered and painted, with new upholstered furniture added to the rooms. She had red velvet curtains added and paintings of famous Americans hung on the wall. Her efforts lasted but a few short years, until the British came by for dinner in 1814, during the misleadingly named War of 1812.

The anecdote of Dolley's escape from the president's house hours before the British ransacked the building is well known. She had been setting dinner

when she got word that the British had made it into the city. She left only hours before they made it to the president's house, where they ate the dinner and proceeded to burn down the house. As she was leaving, she took with her important silver, state papers and a painting.

The famous Lansdowne portrait of George Washington remains in the White House today as the only artifact from prior to the War of 1812. Dolley's memoirs state that she cut it out of the frame to sneak it away from the British. Another set of recollections tells a different story. Paul Jennings, one of the Madisons' slaves, wrote in his book that some servants climbed a ladder to remove the painting and carried it out. Of course, his was an account of a former slave that was published in 1865, and as such, it did not garner much attention.

Dolley was more social than previous first ladies, but she was also political. Dolley wasn't just about staying at home and throwing parties. She attended debates in Congress and was even given an honorary seat in the House of Representatives later in life. Every Wednesday, she would host informal "drawing room parties." She referred to them as "squeezies" because everyone had to squeeze into the room, thanks to their popularity. To keep the women involved, she held "dove parties" for the wives in the city to discuss current events. Ok, maybe she was about throwing parties, but they were political in nature.

Dolley continued her presence in Washington long after the end of her husband's term. Though they retired to Montpelier, their estate in Virginia, Dolley returned to the city after James's death and subsequent financial difficulties. Her house was at the corner of Lafayette Square in front of the White House. She remained a presence in social Washington, with many of the elite leaving the dull receptions prepared by later first lady Sarah Polk to come to Dolley's house.

When Dolley died, the entire city came out to mourn. The government was shut down for the day so that everyone could pay their respects. President Zachary Taylor eulogized her at her funeral, saying, "She will never be forgotten. She was truly our first lady for half a century." This statement cannot be documented, as there is no record of his speech at her funeral, but if its veracity could be proven, it would be the first instance of the term "first lady" being applied to a president's wife.

CHAPTER 2

MARY, MARY, QUITE CONTRARY

Surely, it has more to do with the popularity of the name than any association with nonconformity that the name might provoke. As it turns out, many women who passed through Washington shared more than just a rebellious nature. They shared a first name: Mary.

FIRST LADY MARY IN DEBT

Mary Todd Lincoln, unlike Julia Tyler, may have very much used public funds to contribute to her shopping whims. Much has been written about Mary's personal quirks, mental health and habits before, during and after her husband's time in office, and this book makes no conjecture on her mental stability. But the woman liked to shop, that much is evident.

Her dresses were made to suit her opulent European tastes. Based on the fashions of Empress Eugenie of France, Mary's dresses could cost up to $2,000, the rumored price of her inauguration purple velvet gown trimmed with white satin and French lace. The dresses, with their lengthy trains, were low cut, revealing her décolletage and shoulders, which was a tad risqué for the time, especially for the president's wife. The lanky, small-town president declared to his wife upon seeing the outfit that he'd be more comfortable if there were "a little less tail and a little more neck." It was not just the president who was made uncomfortable by

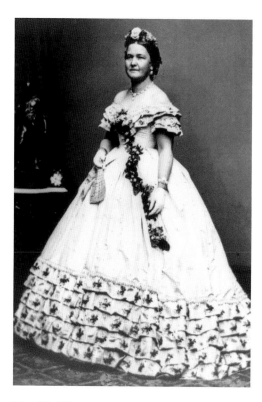

Mary Todd Lincoln in her standard off-the-shoulder dress. *Library of Congress Prints and Photographs Collection.*

these fashions, and the public criticized Mary for "showing off her bosom."

Like Martha before her, Mary was attempting to portray the image of a modern, successful nation and a president who may have been from "out west" but could lead a country filled with metropolitan men and women. Rather than commanding respect as desired, her expenditures led to accusations of pretension and indulgent ways at a time when most of the country was suffering. Her attempts often failed to impress, and she was referred to by William Howard Russell, an Irish reporter during the Civil War, as a "motherly, good natured *grisette en dimanche*"—a working girl in her Sunday best. It began as a compliment, but in the end, it may not have been meant as one. Though later in his correspondence, the same reporter elaborated on his description of Mrs. Lincoln, calling her "a damned old Irish or Scotch (or English) washerwoman dressed out for a Sunday at Highbury Barn."

Mary had to compete for the graces of the Northern society ladies who judged her for being Southern and the Southern debutantes who disagreed with her abolitionist views. Politics aside, in a true nineteenth-century mindset, what better way to prove your standing in society among women than through fashion?

Mary was aware, it seems, of the extra costs to these procurements for her wardrobe. She said, "The President glances at my rich dresses and is happy to believe that the few hundred dollars that I obtain from him supply all my wants. I must dress in costly materials. The people scrutinize every article that I wear with critical curiosity…If he is elected,

I can keep him in ignorance of my affairs, but if he is defeated, then the bills will be sent."

Luckily, he was elected, but the bills were still sent. Mary believed that stores would not call in her outstanding debts if she continued to buy from them, so she kept purchasing more, thus increasing the amount she owed. Illinois senator Orville H. Browning kept a diary, now in the collections of the Illinois State Library, of his time in Washington, mentioning the president's wife and rumors about her. Some of the entries were redacted at the donor's request to protect Mary's reputation, but in the 1990s, they were released in full. These new entries have suggested that in order to fund her purchases, Mary may have altered White House accounts.

In his diary, Senator Browning notes conversations he had with Judge David Davis about the first lady. Davis referred to her as a "natural born thief."

Whether the money was stolen from the public or not, her extravagant purchases were controversial. During the Civil War, her own son, Robert, was safe at school since she refused to allow him to enlist, but hundreds of thousands of other sons were left dead on the battlefields, having fought in horrid conditions without timely pay as their families struggled to survive. Mary Clemmer remarked in her work *Ten Years in Washington* written in 1871, "The wife of its President spent her time in rolling to and fro between Washington and New York, intent on extravagant purchases for herself and the White House. Mrs. Lincoln seemed to have nothing to do but to 'shop,' and the reports of her lavish bargains, in the newspapers, were vulgar and sensational in the extreme."

Mary, however, had new dresses, furs and a reported three hundred pairs of gloves purchased in the span of three months. Who needs three hundred pairs of gloves in the best of times, much less during a war?

To make matters worse, Mary is accused in Browning's diary of conspiring with an employee to pad the accounts by falsifying purchases, claiming reimbursement for personal items and adding to the payroll a nonexistent employee. Another "servant" was hired and paid $100 a month from the government, but there was never an actual hire and Mary pocketed the pay herself. Other sources say that she sold furniture and even manure from the White House stables to raise additional funds.

Though he repeats the rumors and provides details of the accounts, Senator Browning stands up for Mary. He categorically denies that he believes she stole from the White House and calls the claims against her false.

At the time of her husband's assassination, her shopping debt equaled his yearly salary. After his death, Mary arranged with her former dressmaker,

Elizabeth Keckley, to meet in New York on what would turn out to be an embarrassing venture to raise money. Keckley had informed Mary that some of her other clients sold their old dresses secondhand. Since Mary was in urgent need of funds and had a great number of dresses, it could be an option.

When Mary arrived in New York, she checked into the hotel under the name Mrs. Clark and wore a thick veil over her face to keep her anonymity. Rumors easily found their way out when reporters found Mrs. Lincoln's name on her trunks. With scores of trunks filled with her old clothes, Mrs. Lincoln and Ms. Keckley visited secondhand stores, unsuccessfully trying to sell them. Eventually, the firm of W.H. Brady and Samuel Keyes met with Mrs. Lincoln and proposed a new idea.

The men suggested that the American public would not let the widow of Abraham Lincoln struggle so that she would have to sell off her own clothes. If she allowed them, they could petition men of the Republican persuasion to pay for her needs.

It was less a plan to raise money than it was blackmail. Brady and Keyes had Mrs. Lincoln write them letters, addressed as if they were sent from Chicago even though she was in New York, declaring her dire state. These letters were then shown to members of the former president's political party, whom Brady and Keyes thought might pay to keep quiet the fact that the widowed wife of President Lincoln was near destitution. It failed, and no one paid up.

The second plan was to open up the store to display her clothes and place an advertisement in the newspaper so the public would be apprised of the sale. As embarrassing as this would be, she consented. The notice was published in the *New York World* on October 7, 1867, as Mary returned to Chicago.

Rather than bringing her troubles to light, the newspaper article called into question why she was hiding her identity while in New York City. Mary responded in letters to the editor that she was hoping to be afforded the same respect that Empress Eugenie was given when she cast off her worn goods. She reminded the public that many high-profile persons traveling in the city went incognito to avoid publicity.

A woman airing her grievances and justifying herself in public was very much against Victorian protocol, and the public was aghast at these letters. In addition to stating that she needed money, her letters to Brady also pleaded with him to visit Abram Wakeman. Wakeman, postmaster and later surveyor of the port of New York, was "indebted to [Mary] for obtaining the

Mrs. Lincoln's Wardrobe on Exhibition in New York. Library of Congress Prints and Photographs Collection.

lucrative office…from which he amassed a very large fortune…[and] will be only too pleased to relieve [her] by purchasing one or two items." At least, that is how she portrayed it to Brady.

With few goods being sold, Brady and Keyes thought to publish circulars and post them around the country. The plan did not get past the first step when the men could not find prominent citizens willing to be named on the circulars vouching for the sale's authenticity. Failing to bring in the money, Brady set out to arrange a traveling exhibition of Mrs. Lincoln's dresses, but this never panned out either, though today her dresses are on display in museums around the country.

In the end, all that was sold was one diamond ring, two dresses, one set of furs and three shawls, all for only $824, which the men kept as part of their expenses. The efforts of Brady and Keyes, though none of it proved to raise the needed money, cost Mary an additional $820 in charges.

THE REBEL MARY

Even though technically—and any good historian finds joy in the technicalities—Charlotte E. Ray was the first woman to graduate from law school, Mary Ann Shadd Cary was the first woman to enter law school. Mary enrolled at Howard Law School in Washington, D.C., in 1869; she was just unable to get the school to issue a diploma until some fourteen years later.

Mary was known to friends and family as the "rebel" and not because she wanted to be a lawyer. She was an avid abolitionist, suffragist and supporter of equality for all. During the antebellum years, she lived in Canada to escape the threats of the Fugitive Act of 1850. She found her time in Ontario favorable and began to encourage others to join her. She published "A Plea for Emigration or Notes of Canada West," which supported the movement of black Americans to Canada, where they need not be second-class citizens. Unlike others in her situation, she did not see this as a temporary placement but rather believed emigration to be a permanent option.

Mary founded a newspaper called the *Provincial Freedman* in 1853 not only to support the black American community in Canada and extoll the virtues of this option to others but also to raise aid for escaped slaves coming to the country. This was Canada's first antislavery newspaper and first newspaper to be published by a woman. It failed during the Depression, and after the Civil War, widowed from her Canadian husband, she returned to the States.

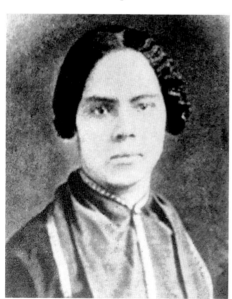

Mary Ann Shadd Cary, a pioneer in publishing. *Library and Archives Canada C029977.*

Her time in Washington was spent living at 1421 W Street Northwest, and her residence is run today by the National Park Service in her memory. She continued to write and published pieces in the *National Era* and the *People's Advocate*, both local abolitionist newspapers. She supported equality for all, regardless of not only race

but also of gender. The Fourteenth Amendment had been passed, which guaranteed the privileges of citizenship to anyone born or naturalized in the United States. In efforts to test the definition of the term "citizen," Mary tried to register to vote in Washington, D.C., in 1871. This was one year prior to the famous suffragist moment in Rochester, New York, when Susan B. Anthony and others were arrested and fined for illegally voting. Mary and the sixty-three other Washington women were not arrested even though the election officials signed affidavits that the women had tried to assert their right to vote. In 1874, she, along with Susan B. Anthony and Elizabeth Cady Stanton, testified to the Judiciary Committee of the House of Representatives for the enfranchisement of women in the District. Mary petitioned that "colored women" be considered in these decisions and that as a District resident, taxpayer and American, she be afforded the same rights granted to men. Though she spoke to the committee, her speech, unlike the others, was not entered into the public record. Her unpublished remarks focus on striking the word "male" from the Constitution to guarantee, under the law, freedom for all.

Mary died in 1893, nearly thirty years before the Nineteenth Amendment granted women the right to vote.

Dr. Mary

Of the nearly 3,400 Medal of Honor recipients since the award was established in the Civil War, only one has ever been awarded to a woman. And that happened in 1865.

The President of the United States of America, in the name of Congress, takes pleasure in presenting the Medal of Honor to Assistant Surgeon– Civilian Mary Edwards Walker, United States Civilian for extraordinary heroism as a Contract Surgeon to the Union Forces. Whereas it appears from official reports that Dr. Mary E. Walker, a graduate of medicine, "has rendered valuable service to the Government, and her efforts have been earnest and untiring in a variety of ways," and that she was assigned to duty and served as an assistant surgeon in charge of female prisoners at Louisville, Kentucky, upon the recommendation of Major Generals Sherman and Thomas, and faithfully served as contract surgeon in the service of the United States, and has devoted herself with much patriotic zeal to the sick

and wounded soldiers, both in the field and hospitals, to the detriment of her own health, and has also endured hardships as a prisoner of war four months in a Southern prison while acting as contract surgeon; and Whereas by reason of her not being a commissioned officer in the military service, a brevet or honorary rank cannot, under existing laws, be conferred upon her; and Whereas in the opinion of the President an honorable recognition of her services and sufferings should be made: It is ordered, That a testimonial thereof shall be hereby made and given to the said Dr. Mary E. Walker, and that the usual medal of honor for meritorious services be given her. Given under my hand in the city of Washington, D.C., this 11th day of November, A.D. 1865. /s/ Andrew Johnson, President

As a woman, she was not officially part of the military and was awarded the Medal of Honor, the highest tribute one can receive, as a civilian, as shown in the citation above. Mary received her medical degree in 1855 from Syracuse Medical College, where all her sisters were learning to become teachers. This was only six years after Elizabeth Blackwell graduated as the first woman to receive a medical degree. Mary opened a private practice with her husband, also a physician, in New York until the outbreak of the Civil War. The practice was not entirely successful, however, as women were not always trusted as doctors.

Wanting to use her medical skills to aid the Union, Mary came to Washington, D.C., to volunteer her services. Despite her advanced training and practice, she was only allowed to work as a nurse. The official reason was her lack of surgical experience, but she was likely turned away because she was a woman. Alongside poet and nurse Walt Whitman at the temporary hospital downtown in the U.S. Patent Office, Mary treated sick and wounded soldiers.

Though she was officially a nurse—an unpaid volunteer at that—the soldiers and some of her colleagues treated her as a physician. The doctor on call before she arrived worked day and night, so it was a relief to him to have a competent volunteer. The surgeon even offered to split his wages with her, which she declined.

A female doctor was rare enough, but Mary had the thought to dress like a man for the convenience. In the beginning, she would wear bloomers under her dresses, which had been popular for a time. Eventually, she just wore men's clothes. During her visits to outlying camps, she did not want to be mistaken for a female volunteer, so she compiled her own outfit. Her "uniform" was an officer's tunic, pants lined with a gold stripe, a felt hat and a surgeon's sash. She

was sometimes seen wearing a bow tie and a top hat. On multiple occasions, Mary was arrested for impersonating a man, but she was proud of this.

Mary finally got her commission as an assistant surgeon a few years into the war. Her work on the field and with civilians behind Confederate lines led to her arrest as a prisoner of war. She was charged as a spy because she was dressed as a man. There is not official documentation that she was a spy for the Union, but it is a common rumor about her.

Along with her manly attire, Mary wore her Medal of Honor until her death. For the last two years, she wore it illegally. In 1917, a review board composed of five retired generals went over every Medal of Honor awarded. Its goal was to confirm that awards were actually given for valid reasons. Since Mary was a civilian, hers was revoked along with over nine hundred others. Some sources say that the army did not ask for the medal back or enforce the rule that she could not wear it, while others say that she just refused to give it back.

Half a century after her death, her family petitioned to

Dr. Mary Walker Edwards, in her usual gentlemanly garb. *Library of Congress Prints and Photographs Collection.*

have her award reinstated. They argued that she was just ahead of her time. Mary already knew that, and when talking about herself, she stated, "I am the original new woman…In the early '40's, when they began their work in dress reform, I was already wearing pants." And an army board agreed. Due to her "distinguished gallantry, self-sacrifice, patriotism, dedication and unflinching loyalty to her country, despite the apparent discrimination because of her sex," Mary's Medal of Honor was reinstated.

Madame Mary

Successful businesswomen in the mid-nineteenth century were few and far between. There were not many professions accepted by society as appropriate for women, and most of them did not lead to prosperity. However, there was one career that was perfectly suited for a woman: prostitution.

At 349 Maryland Avenue Southwest, at what was described as the corner of Four and a Half Street and Maryland Avenue, not far from the U.S. Capitol, where the Smithsonian National Museum of American Indians now stands, was a three-story brick building. Contemporary newspapers refer to it as an "old and well established ranche," a bawdyhouse or "Mary Hall's hades." In the mid-1800s, this was a brothel run by Mary Ann Hall. She moved there in her twenties when it was not the most desirable place in town. The alleyways were home to the poorer working class and were overcrowded and often dangerous. Roads had names like "Murderer's Row" and "Louse Alley."

There isn't much to say about Mary Ann Hall. There is a miniscule written record about her and her house, and the rest came from a pile of historical trash found at the site of her home. In a city with over five thousand prostitutes during the Civil War and numerous rowdy soldiers who hired them, there is only one proven instance of Mary's criminal activities. In 1864, Mary Hall was arrested for running a bawdy and disorderly house. Reports say that when the arrest warrant was delivered, she said she had been expecting it. Witnesses for the prosecution reported numerous instances of men coming and going but no women. Mary's defense seems to be not that it was not a brothel but rather that it was running without her knowledge.

When the Union army provost of the District documented all the bawdyhouses, Mary's was listed as one of the "upper-ten." This was a term used to describe the more elite brothels, those with the finest ladies. Mary

A close-up view of Edward Sachse's 1852 print in *Views of Washington* showing the building used by Mary Ann Hall as a brothel. It is the two-story brick building at the intersection in the center on the left-hand side, just left of the round brick building. *Library of Congress Prints and Photographs Collection.*

had eighteen women working for or with her, making it the largest in the city at the time.

We know that it was a successful institution because of the archaeological evidence found when building the Smithsonian museum. Shards of porcelain and ironstone—expensive materials for the time—as well as remnants of food not common, such as coconuts and berries, and French champagne corks were found. Her proximity to the Capitol, lack of arrests at a time when many brothels were routinely closed and expensive tastes could indicate a close relationship with the government or at least the men who ran it.

For the last ten years of her life, rather than run a bordello, Mary had the house run as a women's health clinic. In a way, it was treatment for the women who had worked with her for the many years before. Mary was quite a successful madam and had plenty of resources to live a life of retirement.

As a well-known and long-term resident of the District, the public opinion of someone running a successful brothel is much more flattering than expected. Her death was reported in the *Evening Star*, which described her as "with integrity unquestioned a heart ever open to appeals of distress, a charity that was boundless, she is gone, but her memory will be kept green by many who knew her sterling worth." Mary Ann Hall is buried in Congressional Cemetery, not far from her establishment, where her estate paid for a beautiful monument.

When she passed away, a court feud by her relatives itemized her assets. When she died in 1886, Mary was worth $87,000 in contemporary terms. Today, that is more than $2 million. She left behind Belgian carpets, an icebox, oil paintings and a collection of red plush furniture. In addition to her house in the city, she had a farm estate in Virginia. In accordance with her profession, she also owned a large number of bedsheets, pillows and comforters.

RUNAWAY MARY

Mary Touvestre, sometimes called Louvestre, is relatively unknown in the world of Civil War spies, but her actions were important to the efforts of the Union. Mary was enslaved early in life but earned her freedom to work as a housekeeper in Richmond. She worked for an engineer in the Confederacy who was rebuilding a captured naval ship.

On April 21, 1861, the Union abandoned the Gosport Navy Yard and set it ablaze. Before all the ships could be destroyed, the Confederate forces took the steam-powered frigate USS *Merrimac*. Renaming it the CSS *Virginia*, it was to be rebuilt as an ironclad ship. The iron plates would prove a better defense to explosives than the previous construction of wood. At this time, ironclads were new to both the Union and Confederate navies.

Mary overheard her employer discussing the plans for this new ship. The Confederate plan was to use the *Virginia* against the blockade by the North, which would be detrimental to the Union efforts. Mary realized the significance of this and snuck a copy of the plans.

Walking more than two hundred miles from Portsmouth, Virginia, to Washington, D.C., Mary snuck through enemy lines to bring the plans to the U.S. Department of Navy's secretary, Gideon Welles. The Union did not realize how quickly the *Virginia* was being built, and this news changed its plans.

Abraham Lincoln had declared a blockade on the Confederacy to keep it from trading and replenishing needed supplies during the war, but the blockade was maintained by wooden warships and would be no match for an ironclad. The CSS *Virginia* would easily be able to break the blockade. The Union was aware of the *Virginia*, just not this new information presented by Mary that it was ready. Union officials had originally hoped to finish their own ironclad, the USS *Monitor*, in order to attack the *Virginia* in the navy yard. Since Mary's plans revealed that the *Virginia* was already being outfitted with guns, this would not work.

With the plans, however, the Union navy was able to hurry the completion of the USS *Monitor*. With the *Virginia* on its way, the *Monitor* left the shipyard in Brooklyn to head south with workmen still on board to finish as it sailed. The two ships met on March 8, 1862, at Hampton Roads on the James River, the first battle of the ironclads in American history. Though logistically, the battle was a draw with damage to both ships, the *Virginia* was never able to break the blockade—something it surely would have been successful in if not for Mary's brave trek to Washington, D.C., with the stolen plans.

REBELLIOUS BELLES

The women of the suffrage movement in the 1910s are the very reason this book is not titled "Wicked." But they were wild for their time, maybe even for our time. There are many different avenues to take and opinions to form on the women's rights and feminist movements. Many would argue that the fight continues to this day, but one battle was won in 1920 by a group of women who spent a lot of time in Washington, D.C.

The women's suffrage movement had many players, too many to name. Its history started far before the Women's Suffrage Procession in 1913 down the streets of Washington and the protests in front of the White House. It took root in places far away from the District, but with the historic vote in August 1920, it ended here.

With the election of Woodrow Wilson, the suffragettes saw an opportunity to appeal to an incoming president for his support. There had been sixty years of efforts by women for the right to vote. In the interim, they had won a few battles. Six western states had already enfranchised women, but the movement was faltering on the national level. Annually since 1869, representatives from the National American Woman Suffrage Association (NAWSA) came to Congress with petitions signed by millions but to no avail.

At 9:00 a.m. on February 12, 1913, a group of women who dubbed themselves the "Army of the Hudson" left Hudson Terminal in New York. Their only weapons their wit, and their only transportation their feet, these women marched 225 miles to get to Washington, D.C. The trek only took them sixteen days led by "General" Rosalie Jones and "Colonel" Ida Craft.

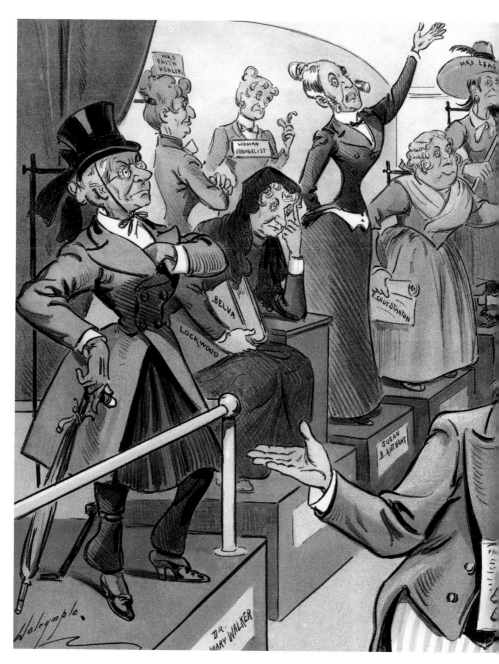

"A Suggestion to the Buffalo Exposition—Let Us Have a Chamber of Female Horrors" depicts male leaders walking through a display of well-known female activists. *Library of Congress Prints and Photographs Collection.*

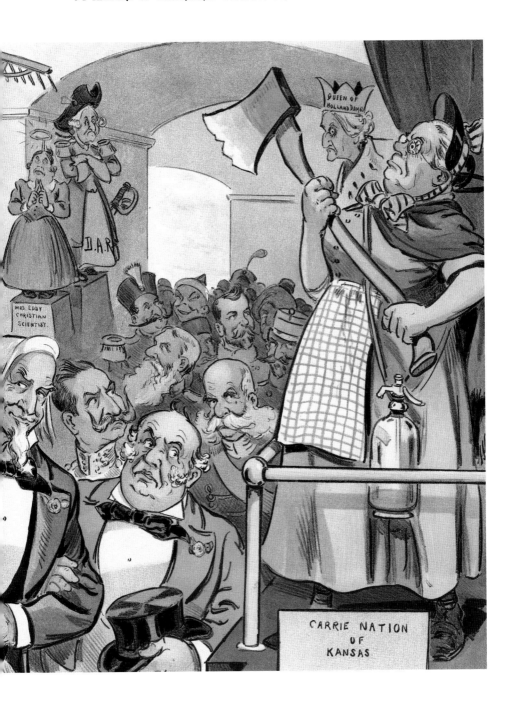

Due to the road conditions, they took a train from New York City to Newark, New Jersey, to begin the march. Colonel Craft thought this was cheating, so she resolved to walk along the train as it journeyed to Newark. Many more women joined the march for different segments and walked on through the trying weather. A short video clip of the start of the journey is preserved and shows the women, escorted by many men and police officers on horseback, in long brown cloaks carrying walking sticks and yellow flags bearing the slogan "Votes for Women." In the video, as the women prepare to start the march, you can see their breath in the frigid air.

Despite poor weather and occasional hassles from anti-suffrage members of the public, the army made it all the way to Washington in time for the Women's Suffrage Procession on March 3. Their arrival in D.C. was less historic than General Jones had hoped. Upon nearing the city, the letter she had carried from New York City to be delivered to incoming President Wilson was demanded by representatives of the National American Woman Suffrage Association. The letter would be delivered by Alice Paul, who had not walked much farther than from her home in downtown D.C.

A true soldier, General Jones said that she would follow orders, though she was obviously disappointed. The pilgrims' march into Washington was given the appropriate permits by the superintendent of the police but was not supported by everyone in the general public. In the more than two weeks of traveling, their reception into Washington may have been the roughest. More than two hundred boys from Maryland Agricultural College lined the streets to jeer and insult the women to the point of tears. They rocked the cars carrying the women's belongings and tore the "Votes for Women" banners off.

Though General Jones did not get a chance to deliver the letter to President Wilson himself, the Army of the Hudson joined the historic Women's Suffrage Procession in the following days.

On a large horse named Grey Dawn and while wearing a crown and a long white cape, lawyer Inez Milholland led thousands of marchers down Pennsylvania Avenue the day prior to Woodrow Wilson's inauguration as president. The exact number of the marchers varies from five thousand to twenty-two thousand, but regardless, it was a significant number of supporters. The route they took from the Capitol Building toward the White House would be used the following day by the president. The women had joined together to "march in a spirit of protest against the present political organization of society, from which women are excluded," as stated in the official program.

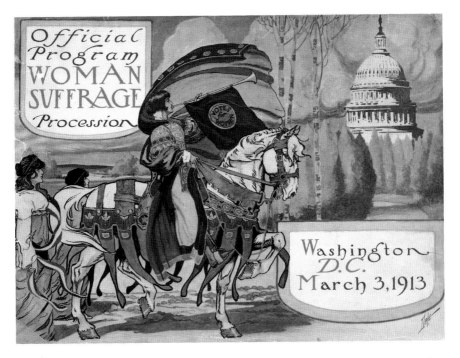

Official program cover for the Women's Suffrage Procession on March 3, 1913. *Library of Congress Prints and Photographs Collection.*

At the place of honor at the front of the parade were representatives from countries that already offered women the right to vote. Behind them were the American women who had struggled for years for this right. Following these pioneers were working-class and professional women in their uniforms—doctors, academics, farmers, actresses and homemakers. Delegates from individual states came next, and lastly were the men who supported the movement.

Just like the Army of the Hudson experienced, the marchers were not entirely welcome. In many instances, the women and men had to force themselves down Pennsylvania Avenue. Protesting the protest, men from the city and in town for the inauguration crowded the streets, at some places only allowing a single-file line of marchers through. They physically and verbally assaulted the women. Two ambulances made continuous rounds between the march and the hospital, fighting their way through the crowd. One hundred marchers were taken to the emergency room. Even those who did not need medical assistance did not escape unscathed. The men supporting the suffragettes bore the brunt of the verbal attacks, with those on the sides

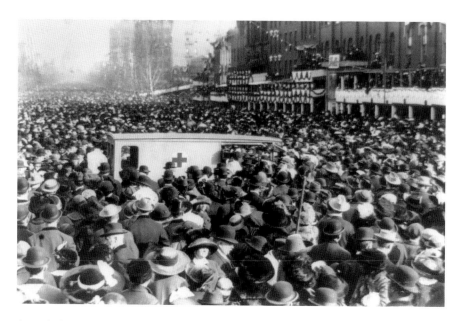

An ambulance crowded by marches and anti-suffrage protestors at the Women's Suffrage Procession. *Library of Congress Prints and Photographs Collection.*

of the march name calling and yelling at them, "Where are your skirts?" In the end, the police superintendent requested aid from the secretary of war, who provided cavalry troops from across the river at Fort Myers.

The police did little to protect the marchers. There were some reports of officers joining in on the taunting. The lack of support only added to the confusion. Twenty-five children were reported to have spent the night at the police station because their parents could not be found. Eighteen husbands came to the station looking for their wives. Such was the chaos that a congressional hearing was called with more than 150 witnesses recounting what happened to them during the events. As a result of the poorly executed police assistance, the D.C. superintendent of police was fired.

In a society that adores drama, the newspapers had a field day with the march and the resulting chaos. All declared that the D.C. police force outraged the nation. In the end, it only brought support for the suffrage movement. The same day as the parade, Wilson arrived in Washington by train. Nobody was there at the train station; they were all at the parade.

Alice Paul never delivered the letter that the Army of the Hudson brought all the way from New York. She did meet with Wilson two weeks after his

inauguration but instead spoke to him on the matter. He said he would consider the proposal, as he had never given it much thought before.

Alice was the newly appointed chair of the Congressional Committee of the National American Woman Suffrage Association. She rented out a basement office at 1420 F Street Northwest to begin her work. Before this, the NAWSA had no official headquarters. It only took her two months to raise the more than $14,000 to fund the Women's Suffrage Procession that she organized to commandeer some of the press coverage in town for the inauguration.

Taking It to the Next Level

Though American, Alice Paul had spent some time in prisons and on hunger strikes as part of the British women's suffrage movement. When she returned to the States, her previous incendiary tactics influenced her association with the NAWSA. She wanted to focus more on drastic actions to get votes at the national level, whereas the association worked at the state level. While the NAWSA supported Wilson, Alice wanted to make it clear that women were not happy with his lack of movement in their cause.

Alice split from the NAWSA and formed the Congressional Union for Women's Suffrage. Wealthy heiress Alva Belmont had contributed financially to many suffrage movements, included the NAWSA, but she also founded her own Political Equality League. Splitting from the unspoken policy of the NAWSA to focus on middle-class white women, Alva supported black American women's efforts in the movement as well. Alva's Political Equality League and Alice's Congressional Union joined in 1916 to form the National Women's Party (NWP). The NWP was still criticized for its singular focus on women's rights while ignoring the racial line.

Alice, particularly, would diminish black American women's contributions in order to appease the southern members of the NWP. The original order of the procession in 1913 had black women walking behind the men at the rear of the parade. In the end, they walked with the representatives from their states, just as the white women did. Alice justified any controversial actions by saying that racial issues were beyond the scope of what she was fighting for.

The first president of the National Associated of Colored Women, Mary Church Terrell, did not accept the lack of effort for enfranchisement of

Mary Church Terrell, a suffragette for black American women's rights in voting and education. *Library of Congress Prints and Photographs Collection.*

black women. Mary was one of the first black American women to finish college. She was a high school teacher and principal in Washington, D.C., when she became the first black woman to hold a position on a school board of education. As an active member of NAWSA, she wanted it to continue the fight for the enfranchisement of all women, regardless of race. When the group was not doing enough, she joined Alice and Alva's National Women's Party in taking these efforts to the next level.

The NWP arranged for female picketers, including Mary Church Terrell, to stand outside the White House continuously. Referred to as the "Silent Sentinels," they were often disregarded. Wilson would smile at them as he passed by, but he made no progress on women's rights. When World War I broke out, the women continued to protest, but this time they were arrested for blocking traffic.

The suffragettes refused to pay the fine and were sent to a workhouse in Virginia. When they refused to eat, they were force-fed. Their cells were cold, damp, dirty and infested with rats. The women were beaten, and officials tried to get Alice declared legally insane. One of the women, Dora Lewis, was thrown into a cell where she hit her head on an iron board. Her roommate thought that Dora was dead, and the panic led to a heart attack. When the press got wind of these events, the public was again outraged at the treatment of the women, many of them old and frail before their imprisonment. Again, the brutality of the police only brought more support to the movement.

All of this was happening during the "War to End All Wars" in Europe, but at home, President Wilson had to also fight the war of public opinion on

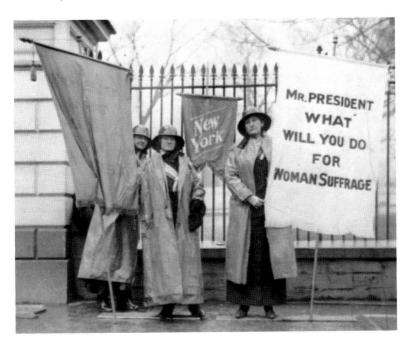

Women picketing outside the White House for women's right to vote. *Library of Congress Prints and Photographs Collection.*

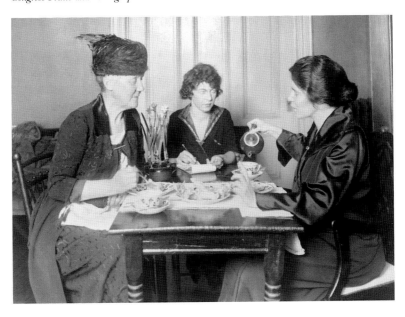

Alice Paul and Dora Lewis, members of the "Silent Sentinels," are seen holding a conference, with D.C.'s young lawyer Pauline Floyd acting as secretary, at the headquarters of the National Women's Party. *Library of Congress Prints and Photographs Collection.*

women's suffrage. In 1917, he officially announced his support for the right to vote for women. He called it a "wartime measure." During the war, over thirty thousand women served in military positions. Not on the front line, these women worked mostly in clerical positions and as nurses, though these were still difficult positions and often not far from the battles.

With the public support and proof that women could do a "man's job" just as well—we won the war, after all—Congress passed the Nineteenth Amendment in 1919. It was ratified by the majority of states and signed into law on 1920.

Many women were satisfied with the right to vote and returned home, but Alice and Alva continued to work for equal rights for women. In 1929, as president of the NWP, Alva purchased a house at 144 Constitution Avenue Northeast as the organization's headquarters, and the building still stands today as the Sewell-Belmont House. The Equal Rights Amendment brought up by Alice in 1923 was introduced every year in Congress until it was finally passed in the 1970s. Today, the NWP is no longer a lobbying organization and works to educate the public on women's rights and the historic movement.

PIONEERS IN PETTICOATS

Women in any profession were rare in the nineteenth century. There were only certain jobs that society believed a woman could do, but as the years went by, certain progressive women took a stand to prove they could do anything just as well. From photographers to lawyers and doctors, some women shared the stage with men, petticoats and all. And as we saw, some women, like Dr. Mary Edwards, literally wore the pants.

A BEER STEIN AND A CAMERA

The daughter of a female *Baltimore Sun* drama critic and political correspondent, Frances Benjamin Johnston knew from an early age that women could work in professions normally reserved for men. When a family friend gave her a gift of his new invention, Fannie, as she was called, was on a new path. George Eastman, founder of the Eastman Kodak film and camera company, gave her a small camera. Her interest in photography grew under the tutelage of the director of photography at the Smithsonian and later the Academie Julien in Paris and Washington Students League.

Fannie started out taking photographs of friends and family, but thanks to her family's connections, she was able to work as a professional photographer, with many prominent citizens as her subjects. This is not to say that her work would not have gained its reputation without her mother's political allies. As

a woman in the 1890s, a foot in the door helped, but it was her own tenacity that furthered her career.

On the streets of New York City, she was intrigued by the sign for the *Demorest's Monthly Magazine*. She walked right in to show some photographs to the editor. He was interested in running a piece on how money was made, and while he was interested in her work, he wanted someone who could write as well as photograph. When asked if she had experience in writing accompanying pieces, she replied, "I have not, but I can." She got the job.

Her newspaper work began here, and she continued to write and provide illustrations for *Cosmopolitan*, *Frank Leslie's Magazines* and *Harper's Weekly*. Eventually, her work brought her around the world and focused more on her photography. When Admiral Dewey was coming home from Manila, she was chosen to photograph his triumphant return. New York governor Theodore Roosevelt met with her one day at the beach at Oyster Bay. Newspapers report that he came running from the surf in his bathing suit to give her a letter of introduction, and she was on a ship the next day for Italy. Fannie was the first American newspaper photographer in Naples, the same day that the admiral arrived. Fannie photographed him on the deck of the USS *Olympia* and documented many of the ship's contents, including a canary that lost its leg in battle. These photographs were some of the first the American public saw of their hero of Manila Bay in the Spanish-American War.

In 1894, Fannie opened up a photography studio at 1332 V Street Northwest. At this point, she was the only female photographer in Washington, D.C. Her advertisement for the studio states that she "makes a business of Photographic Illustration and the writing of descriptive articles for magazines, illustrated weeklies and newspapers." Producing more than just photographs, she was appealing to the public's taste for illustrated art.

Coming from a well-known family may have helped, but Fannie is remembered today as one of the premier photographers, female or otherwise, of her time. She was nicknamed the "Photographer of the American Court," referring to her portraits of Mark Twain, Booker T. Washington and Alice Roosevelt in her wedding pose and her work as photographer to Presidents Cleveland, Harrison, McKinley, Roosevelt and Taft. Though she took a profile portrait of Susan B. Anthony, it's not the most familiar one from the U.S. dollar coin. As photographer of the Pan-American Exposition in Buffalo, New York, in 1901, she captured the last image of President McKinley minutes before he was assassinated.

Fannie is best remembered for her work as a documentary photographer. As her career grew, rather than taking photographs for the sake of beauty or portraits of those who could afford them, she documented places, buildings and scenes soon to be lost. This grew out of her experience as a newspaper photojournalist, but she did not do this for the sake of stories but rather to keep the memories of these places alive.

She was commissioned by Booker T. Washington to photograph the Hampton Institute in Virginia. Later, she did the same for the Tuskegee Institute. Her focus turned to architectural photography when she noticed that many historic buildings were failing into disrepair. She said, "Many places are in a state of great dilapidation, with walls crumbling, roofs falling in, occupied by the poorest of the poor—tenants usually of indifferent owners; or by contrast more completely destroyed by so-called 'improvements.'" With this attitude, she recorded schools, churches, homes and even towns as a whole, mostly in the South. She was given grants and hired by the Library of Congress to continue this work until the gas shortage of World War II forced her to slow down, if not stop altogether. These thousands of photographs not only keep a record of places long lost but also do so with such artistry that her composition and lighting is still admired today.

Fannie was a pioneer for female photographers. One of the first to reach the status in the profession that she did, she was well aware of her place as a role model. Fannie wrote an article for the *Ladies' Home Journal* titled "What a Woman Can Do with a Camera," in which she said, "Photography as a profession should appeal particularly to women, and in it there are great opportunities for a good-paying business." She continued, however, detailing just what it takes to be a professional photographer:

> [It is] *a good-paying business—but only under very well defined conditions. The prime requisites—as summed up in my mind after long experience and thought—are these: The woman who makes photography profitable must have, as to personal qualities, good common sense, unlimited patience to carry her through endless failures, equally unlimited tact, good taste, a quick eye, a talent for detail, and a genius for hard work. In addition, she needs training, experience, some capital, and a field to exploit. This may seem, at first glance, an appalling list, but it is incomplete rather than exaggerated.*

Photography is not a profession well suited to women because it's easy or geared to those with an eye for beauty; rather, she details how it is neither of those things.

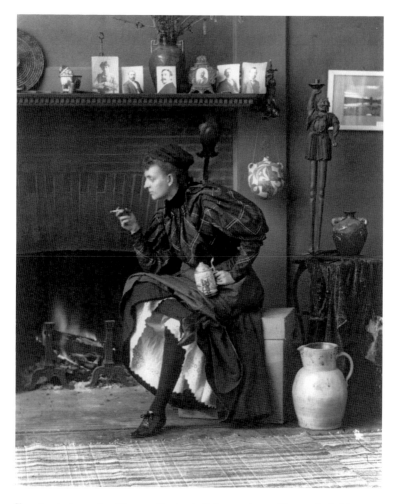

Female photographer Frances Benjamin Johnston in a self-portrait defying a woman's role by crossing her legs like a man and holding a beer stein and cigarette. *Library of Congress Prints and Photographs Collection.*

Fannie did not want to discourage women photographers, however. She was one of only two American female photographers included in the 1900 International Congress of Photography in Paris, France, held in conjunction with the Universal Exposition. While she was there, she curated an exposition of American female photographers, displaying more than 150 works from thirty women across the country. Focusing on the diversity of female photographers and in support of others following her footsteps, she did not include any of her own work in the exhibition.

Frances Benjamin Johnston did not need a husband to pay her way as she quite successfully created her own business and dominated her field. As a representation of the "New Woman," Fannie's most well-known self-portrait is one of her holding a cigarette and beer stein with her petticoats showing. These were things that women of her social standing did not do at the time—but then, they also weren't professional photographers.

A Common Scold

Anne Newport and her mother were servants in the home of Virginian Revolutionary War major William Royall. The major hired the girl twenty years his junior but also gave her full use of his library, much like a father figure taking interest in her education. Twelve years later, however, his interest was in more than her mind, and the two were married.

Despite the age difference and the humble beginnings of his new wife, the two were content in their married life until Royall's death fifteen years later. The gentleman farmer left considerable wealth to his wife, much to the dismay of his family. They petitioned the court that the two were never legally married and thus the will was a forgery. The courts eventually sided with the family, leaving Anne Royall with nothing.

Fortunately, the only legacy from her husband that Anne needed was the education he provided for her. With the death of her husband as impetus to leave home, she traveled to the new state of Alabama, where she wrote letters to friends. These were eventually compiled into *Letters from Alabama*, her first written work as a travel writer. Writing was not a reliable living for a woman at the turn of the nineteenth century, however, so Anne came to Washington.

As a widow of a veteran, she had to appear before Congress to petition for a pension. It would be nearly twenty years before this was granted, but to the courts, she was never legally married, so the Royall family ended up receiving this as well. In those years, however, Anne would make a name for herself as the first female journalist.

The story of how she got started may be unsubstantiated, but it's a good story nonetheless. President John Quincy Adams, in a time before Secret Service and presidential entourages, liked to enjoy a morning ritual of a swim in the Potomac River. It was also a time before river pollution. A skinny-dipping president was caught off-guard when he found a small and

stout woman sitting atop his clothes. She refused to give them back until he answered her questions. Thus began the first interview of a sitting president by a woman. It was probably, hopefully, the only interview done while the president was nude.

John Quincy Adams later forgave Anne for this incident and seemed to like the woman, though he called her "the virago errant in enchanted armor." She would eventually interview every president from John Adams to Franklin Pierce. Antebellum America, especially in the South, was geared more toward gentility and proper social decorum, but Anne was brash and straightforward in her writing.

Using the Masonic connections of her late husband, Anne traveled through the States earning no money but writing down everything she could. A collection of sarcastic observations on the American people, her *Sketches of History, Life and Manners in the United States* was published when she was fifty-six years old. The work on her visits to the northern states was essentially details from her times as a single female traveler and her often caustic observations of the people she met. A work similar to Fodor's travel guides today, she commented on cities' populations and transportation methods and even shared stories of greedy innkeepers who tried to charge her too much. Depending on the audience, it was either well received or demeaned as the musings of a "poor, crazy vagrant."

These observations were compiled into a collection called the "Black Books." In the second of these regarding her southern travels, Anne has the first written documentation of the term "redneck." She states that it is "a name bestowed upon the Presbyterians in Fayetteville." Anne did not have a great history with Presbyterians. When she moved into her home on Capitol Hill in Washington, D.C., it was next door to a federally funded firehouse. Anne was very much in favor of the separation of church and state, so when a Presbyterian congregation began using the engine house for services, she objected. She claimed that the children pelted her window with rocks and congregation members prayed under her window, trying to convert her. Being a writer, her first action was to write about these people. She gave them nicknames like Holy Willy, Young Mucklewrath and Hallelujah Holdfork. As their praying got more distracting, so did her responses, and she began to curse, which at the time was apparently illegal. The parishioners filed a complaint to the district attorney, and Anne was arrested. While the court and prosecution took this seriously, Anne and her friends did not. Doorkeeper of the Senate Mr. H. Tims was called in her defense, and when asked if he knew of her slandering anyone, he replied, "There is Mr. Watterson. She

said in the same book that he and Joe Gales are the two handsomest men Washington. Now I leave it to all the world if that is not slander!" She would be found guilty of this public nuisance and became the first American legally declared a "common scold." The marines down the road at the barracks built a ducking chair to carry out her punishment, but the courts decided that sentence was no longer relevant to the time, and she was instead fined ten dollars. Embarrassed by this incident, Anne left D.C. to travel south and complete additional stories on her sojourn, where she met the Presbyterians in North Carolina whom she referred to as "red necks."

This was one of many colorful names she documented for Presbyterians. Others included "black coats," "blue-skins" and "copper heads." Her not-so-friendly relationship with this Christian sect began with one man, Reverend Ezra Ely, who also did not get along with one of the other wild women documented in this book, Margaret Eaton. Maybe it was because the women had a common enemy, but Margaret's husband, Secretary of War John Eaton, testified on Anne's behalf at her trial. Reverend Ely and those with stricter Christian views were trying to bring religion back into the government by electing like-minded politicians, but Anne decried this action and revealed their political plot in her writings. From then on, the Presbyterians, especially Reverend Ely, provided little support for her works.

In fact, it seems Anne's writing often made her enemies. She considered herself a guardian of democracy, a whistleblower of her time. Supported by the *National Intelligencer*, a prominent D.C. newspaper that provided her with the type, Anne began *Paul Pry* in 1831. The four-page newspaper detailed instances of waste, greed, nepotism and laziness in the government. Where politicians were found wanting, she would remind everyone that the inadequately used funds could be used for widows' pensions—she was still waiting for hers—or orphans, whom she hired to help set her print for *Paul Pry*. Anne seemed difficult to please. She supported Andrew Jackson but vehemently opposed his policy toward Native Americans. Personally, she was against slavery and the excess of alcohol. However, Anne found the abolitionist and temperance movements to be too much outside the vein of church and state separation that she favored.

Eventually, *The Huntress* succeeded *Paul Pry*. New name, same ideals. *The Huntress* remained in print until Anne died in 1854. She was buried in an unmarked grave in Congressional Cemetery until a marker was placed in her memory in 1911. The prospectus of *Paul Pry*, one of her many legacies, stated what Anne dedicated her life to documenting:

We shall oppose and expose all and every species of political evil, and religious frauds without fear, favor or affection. We shall patronize merit of whatever country, sect or politics. We shall advocate the liberty of the Press, the liberty of Speech, and the liberty of Conscience. The enemies of these bulwarks of our common safety, as they have shown none, shall receive no mercy at our hands.

And perhaps as a call to those who prosecuted her in the past, she reminded them, "Let all pious Generals, Colonels and Commanders of our army and navy who make war upon old women beware."

No Ordinary Soldiers

Many women at the outbreak of the Civil War did not know how to support their favored side. The roles of women at the time were limited, and none of them included direct involvement in the war. Though the true number is likely much higher, we know of at least four hundred women who disguised themselves as men to join the troops. Some were following brothers or husbands, while others served out of a sense of patriotism or in search of adventure. We know them because of their memoirs or because they were found out when wounded or killed in battle. For some of them, we have both the true name and their masculine alias, and others are known only by the name their fellow soldiers knew them by before they died on the field.

More than a century later, we are still finding out about some. In the 1990s, a stash of letters was remembered in an old attic in New York. They were letters home from a soldier fighting with the 153rd New York Volunteer Infantry. The Wakeman family lore told of a grandmother, still living after the war, who had mentioned a sibling who fought under the name Lyons Wakeman, but not much more was known. The letters were from a Sarah Rosetta Wakeman. It wasn't until the 1970s that the connection was made, but it was still forgotten again for twenty years. To the Wakeman family, it was known that Rosetta had joined the Union under the name Lyons in the disguise of a man. To the rest of the world, Lyons Wakeman was simply a soldier who died during the war and is buried under the military headstone 4066 in Chalmette National Cemetery in New Orleans.

Rosetta, as she was known, was the eldest daughter of a large farming family in New York. As she grew older, the family grew more in debt. Thinking it the best way to serve the family, she left home and struck out in the guise of a man to earn a living. Jobs that were open to women, such as that of laundress, did not pay the wages she needed to help support the family. She began work as a boatman on a canal, where she met recruiters for the 153rd New York Volunteers. They told her she could earn a $152 bounty—think of it as a signing bonus—and $13 a month pay. She enlisted on August 30, 1862, as a private and sent some of the bounty home, telling the family to buy clothes and food.

To protect her identity, she had her family mail the letters addressed only to R.L. Wakeman. However, she signed them Rosetta, even saying that her family need not worry what they say in the letters as they are read by no one but herself.

In the letters, she does not talk much about her reasons for leaving other than helping her father pay his debts. Nor does she talk much about the war as a whole, though she often asks her family their thoughts. She does at one point mention that she thinks the war will continue because the officers are making a pretty penny with their salaries. If they were to receive her pay of only thirteen dollars each month, it would be over already.

The first post for the 153rd was in Alexandria, Virginia, as guards for the defense of Washington. They were here just under a year when the New York Draft Riots happened. President Lincoln needed more men, so Congress passed a draft. The middle- and lower-class workers of New York rebelled against this act—the story behind *Gangs of New York*. Fearful that the same thing would happen during Draft Week in Washington, Rosetta's troops were brought into the city and stationed on Capitol Hill.

Rosetta described the job that her company performed. On a rotating schedule, the soldiers guarded Carroll Prison; the Baltimore and Ohio Railroad Depot; city hall, where the draftees were registered; the city; and the camp. From August to October 1863, she was at Carroll Prison every other day. Carroll Prison was used as the Capitol Building decades earlier and has been subsequently called the Old Capitol Prison. She comments in a letter home about three women held there. One was a Confederate major who had ridden once into battle with her men, while the other two held as spies were likely famous Southern spy Belle Boyd and a Rebel mail carrier whom Belle named as Ida P.

During its time in Washington, the 153rd practiced drills just as any regular regiment. Rosetta claimed she had "got so I can drill just as well as any man there is in my regiment."

In February 1864, her regiment was given marching orders south to Louisiana. After fighting at the Red River campaign and a seventy-mile forced march after, Rosetta was admitted to the hospital with chronic diarrhea, and she died in May 1864. What seems such an unjust fate for a soldier was one of the deadliest diseases during the Civil War. The 153rd would a few months later return to Washington to defend against Confederate general Jubal Early's attempted invasion and the review of the troops by President Andrew Johnson after the war.

If her letters home had not been preserved, historians would never know that Lyons Wakeman was truly a woman in disguise. How many other female soldiers are buried under their enlisted names or unmarked graves we will never know. What we do know is that there were many other women just like Rosetta Wakeman.

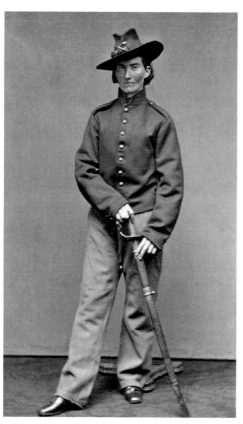

Portrait of Frances Clalin Clayton, disguised as a man in a Civil War uniform, fighting under the name of "Jack Williams." *Library of Congress Prints and Photographs Collection.*

Frances Clalin Clayton, under the alias Jack Williams, joined the Missouri forces with her husband, Elmer. She easily joined the rank-and-file soldiers as "Jack Williams," and the masculine-looking woman made the effort to learn to smoke cigars and play poker. When her husband died in battle in 1862, she was said to have stepped over his body to continue the fight when the order to charge was called. We know little about Frances other than the fact that she did at the very least have a carte de visite taken of herself in a Union uniform. The last rumor is that she was headed for Washington, D.C. Whether she made it, we do not know.

While Frances was fighting for the Union at Fort Donelson, Tennessee, on the Confederate side was another woman in

disguise, Loreta Velasquez, fighting as Lieutenant Harry Buford. In a perfect example of how history can change based on who is telling it, not much is known about Loreta that is verifiable. We have her memoir, *A Woman in Battle*, which goes on in great depth about what she did without ever actually providing any details. Very few full names or dates are written in the published work. Those who were fully named in the book, written in 1876, had all died in the war and could not be interviewed as to its veracity.

The book was also advertised in a rather misleading manner. A letter from Mark Twain to a friend, the editor of the *Courier-Journal*, asks that the newspaper be warned that a woman named Mrs. E.H. Bonner, who recently wrote a book about her time as Lieutenant Harry Buford, was claiming that he was collaborating on it. Twain says that she did ask, but he declined. Twain called her a fraud, not for what she had written but for saying he was involved. In typical humorous fashion, he said, "Now, I do not want the public to be defrauded in my name, except when I do it myself—& not then, when I know it."

At the time, it was criticized by many who said it was not and could not be true. One of them was Confederate general Jubal Early. Though he did not know Harry Buford personally, Early claims that what had been written was false, regardless of whether it was written by a man or woman.

Herein lies the beginning of the problem. Early was essential to the memory of the Confederacy. He was one of the most vocal advocates for the "Lost Cause of the Confederacy." While he was romanticizing the Rebel soldiers as chivalrous gentlemen, Loreta was detailing how vulgar and uncouth they were. Not only were they loutish, she was proof that they were not all gentlemen or even men at all. Loreta's writings show how the war was more about money and greed than states' rights or the abolition of slavery.

The remarkable story of Loreta's escapades as a soldier and a spy is almost unbelievable, making it easy for the public not to trust her accounts. It was labeled a hoax and is considered as such to this day. Modern historians are trying to revive her memoirs, still in print, as based mostly in truth. Now that we know of so many other female soldiers in the Civil War, Loreta's accounts are not as fanciful as they first seemed, but it is still hard to corroborate her claims.

Loreta led her life in disguise. To some she was Loreta Janeta Velasquez, a Cuban immigrant who lived with an aunt in New Orleans until she ran away to marry a Texan named William. To others, she was Lieutenant Harry Buford, a courageous soldier who was wounded four times in battle. Buford

saw action at the First Battle of Manassas (or Bull Run, depending on who you are talking to), Ball's Bluff, Fort Donelson and Shiloh. Yet still to others she was Mary de Caulp, wife of a Confederate captain who happened to be Harry Buford's commanding officer—though Captain de Caulp did not realize at the time that his wife and his lieutenant were the same person. To Samuel Clemens, she was Mrs. E.H. Bonner, author of the book about Harry Buford's experience in the war.

For Lafayette Baker, head of the Washington, D.C. branch of the Federal Detectives Corp, she was Mrs. Alice Williams. General consensus among historians today seems to imply the Mrs. Alice Williams is the same Mrs. Williams that Loreta says she used as an alias. In the interest of full disclosure, Loreta never identifies the first name in her memoirs but just states the very common surname of Mrs. Williams. That is not to say these historians are not correct. A July 21, 1863 article from the *Staunton Spectator* in Virginia relays the arrest of Mrs. Alice Williams, who soldiered under the name Lieutenant Buford.

After being wounded in battle at Fort Donelson, Loreta went to Richmond as Buford. Here she was discovered, because the head of the Confederate Secret Service was suspicious of everyone. She was arrested as a Federal spy and imprisoned at Castle Thunder—where Dr. Mary Walker Edwards was also held. Eventually, she was released and recommended to the Confederate Secret Service to work as a spy.

As Mrs. Williams, Loreta came to Washington, D.C. She stayed at the Brown Hotel while she surveyed the troop movements and area defenses. While in the city, Loreta heard that the Federal Detective Corp was looking for more agents. What better way to spy on the Union for the Confederacy than to spy on the Confederacy for the Union? It took months of visits to Baker with tidbits of information and reassurances of her skill for her to be given a mission as a spy for the Union. Thus began her time in Washington as a double agent.

Being an agent for both the North and the South proved confusing for both governments. On a trip, Loreta was working a task for both sides. For the Confederacy, she was transporting documents and a large amount of cash from Richmond to Canada. For the Union, she was in Richmond trying to identify a Confederate prisoner held up north in a Union prison who was somehow leaking information to the South. On the train ride to Canada, she realized there was a certain gentleman conducting a search for a Rebel spy—her. He sat next to her and had a conversation about his search for this woman, never realizing it was her he was looking for. He said that the

spy was on her way to Canada with a large sum of cash that he would surely like to get his hands on. And he did, when he chivalrously carried her satchel filled with $82,000 off the train for her.

While the detectives searched for her up north, Loreta returned to Washington, D.C. She rented a room at the Kirkwood Hotel, the residence of Vice President Andrew Johnson on Pennsylvania Avenue Northwest. After providing information to Baker on her trip to Richmond (ignoring the subsequent trip to Canada), she spent the evening socializing with him and a general. They attended a play at Ford's Theatre and had supper at the Grand Hotel. In her memoirs, Loreta relates her discomfort at the evening. She was concerned for her safety but mostly could not help but think of the poor Confederate soldiers on the field while she was at the theater and having a delightful meal. She did, after all, know exactly what life for these soldiers was like.

A later stay in Washington revealed "gross immoralities" in the U.S. Treasury Department. Loreta used this to her advantage. She met with a treasury employee under a cedar tree in front of the Smithsonian Institution. The employee was for the Union but didn't see anything wrong with making some money off it. He provided her with a plate for $100 compound interest notes as well as treasury paper. Using these, she made thousands of dollars worth of counterfeit Confederate and Union securities and money that was exchanged for British gold and then for U.S. greenbacks.

Loreta's last mission for the Union and Baker was a unique request. About a year earlier, Baker had mentioned to her a female Rebel spy who his detectives were after but could not find. He joked that if she continued her success, he would assign the task to her. That task would be to find herself. It just so happened that she continued to impress him and continued to elude his other detectives. Shortly after the assassination of President Lincoln, Loreta was in Washington, D.C., and given the request by Baker to find this slippery female spy.

She did not immediately accept, not sure how the situation would play out. In the course of making her decision, her brother proposed that as the only two remaining family members, they go to Europe to wait out the unpleasantness falling upon the States. Loreta saw this as an escape. She agreed to Baker's request, finding out how much they knew of her movements and how close she had come to being captured in the past. Buying the time she needed to escape one last time, she headed to New York on Baker's mission, and from there, she left for Europe.

After some time in Europe, she no longer had a need to fear capture by Baker. He unexpectedly died of what is thought was arsenic poisoning.

Lafayette Baker was one of the few who could verify Loreta's stories. Though he may have used her as a spy, in her memoirs, she claims he wanted her to be a secret agent and not reveal her to the rest of the detective corp. The only other man present in the conversation was a Union general whom Loreta only referred to as General A. There were twenty-three generals whose surnames began with A, and even if we figured out which one she meant, it's far too late to ask him.

FULL-FLEDGED LAWYERS

In March 1919, the front page of the *Washington Times* shared the story of a "Pretty D.C. 'Stenog' Now a Full Fledged Lawyer." There are few instances in which the press refers to a male lawyer as pretty—well, let's be honest, there are none. But this was a time when female lawyers were rare, and this pretty new lawyer was only twenty-one years old.

Pauline Floyd was born and raised in Washington, where she attended public schools before going to college at the Washington School of Law. Founded in 1896 by Ellen Spencer Mussey and Emma Gillett due to a lack of legal education opportunities for women, the Washington School of Law was not meant to be a full-fledged university. Ellen had graduated from Howard University Law School, after being denied entrance to Columbian College, which would become George Washington University, and National University School of Law, even though she had apprenticed at her husband's law firm.

The first Woman's Law Class was held in Ellen's law office with three other women. Two years later, there were more teachers and a few more students, but it was still not an official school. Emma and Ellen asked the law school at Columbian College of Law to accept the women for their final year of study, but they were denied entrance because women "did not have the mentality for law." That encouraged the women to take matters into their own hands, and in April of that year, the District incorporated the Washington College of Law. It became the first law school in the world founded by women, to have a female dean and to graduate an all-female law school class. Though the college was founded with the aim "to provide such a legal education for women as will enable them to practice the legal profession," the first male student had enrolled the year before the school was incorporated.

Pauline specialized in domestic relations while at Washington College of Law and took the bar in January 1919. Once she passed, she became the youngest female lawyer in Washington; some at the time said she was the youngest female lawyer in the country. She entered the divorce practice, hoping to aid women in their attempts to get out of failed marriages.

The laws of the District, however, were antiquated and in favor of men. The only cause for a woman to be granted a divorce was adultery, but the burden of proof was on the woman. Pauline had a solution: "Of course, I know it's an old, old idea, but if men and women knew that either the husband or wife could get a divorce for the asking, each would exert himself more to hold the love of husband, or wife, as the case may be."

Shortly after this quote was published in an interview in the *Washington Times*, Pauline received a proposition from a Virginian postmaster and landlord. He claimed that a woman could be granted a divorce if she resided in Virginia at least one day a week for a year. It just so happened that he had a home in Fairfax that could accommodate forty women, and he already had two there. Once the women lived there for one year, paying him ten dollars a week, Pauline could represent them in court to obtain the divorce. Pauline gets paid her lawyer fees, the postmaster gets paid rent and the women get their divorces—everyone wins.

The "divorce club" never materialized, and Pauline eventually left Washington. There was little work for a young female lawyer specializing in divorce. A 1922 record states that she had yet to lose her first case, but it doesn't say how many cases she had had in the meantime.

Pauline may have been the youngest female lawyer, but she was not the first.

Genesee College had no law department, but when a local law professor opened a private class to area students, Belva Ann Bennett attended. This small course in law stoked her desire, and within a few years, Belva had moved to Washington, D.C., with her daughter with the hope of finding a legal education. Here she met and married a progressive gentleman who supported her efforts in education, Ezekiel Lockwood. Just as Emma Gillett and Ellen Mussey discovered, though Belva tried before them in 1870, the local law schools said she would be a distraction to the male students. The National University Law School eventually let her and other women attend, though when they finished their courses, the school would not grant the women diplomas. Without diplomas, these women would not be admitted to the bar. Despite years of coursework, Belva had to report to an examining committee of the bar. She did this twice, each exam lasting three days, and yet neither committee would pass or fail her. The committee simply refused to acknowledge her.

So Belva petitioned to the president ex officio of the university, who happened to be the president of the United States, Ulysses S. Grant. She boldly demanded his action in a simple letter:

> *SIR,—You are, or you are not, President of the National University Law School. If you are its President, I desire to say to you that I have passed through the curriculum of study in this school, and am entitled to, and demand, my diploma. If you are not its President, then I ask that you take your name from its papers, and not hold out to the world to be what you are not.*

Within a week of sending her letter, Grant issued Belva Lockwood her diploma at the age of forty-three.

Though she was admitted to the District of Columbia bar, she was not accorded the same privileges associated with this honor. She was a married woman and, by the legal definition, was subordinate to her husband and men in general. Though she won a few cases, she was told by many, even judges, that women were not meant to be lawyers. One judge commented that he welcomed female lawyers because he didn't believe they would be successful. In some ways, he would be right. Belva was not the first woman admitted to the District bar. For the 1870s, it is remarkable that a woman was admitted at all, but the first woman was Charlotte E. Ray, a black American woman who had graduated from Howard University Law School. Historians debate whether she simply used her initials, C.E. Ray, rather than her full name and was admitted because it was not realized that she was a woman. Nonetheless, she opened her own practice but found that prejudice kept her from making a sufficient living.

Belva, however, already had cases. She saw the outrage of the "gentleman's" court as good advertising. They always say that any publicity is good publicity. After three years as a member in good standing of the District of Columbia courts, she was eligible for admittance to the Supreme Court bar. The law made no reference to "man" or "male" but only stated that any attorney could be admitted after three years. Despite the wording and being introduced by members of the bar, she was not granted the honor. Belva appeared before the court multiple times, each with the reply, "But you're a woman!" before it was finally ruled that the court could not admit a woman without special legislation.

So Belva got special legislation. It took six attempts before the bill was finally passed in Congress on February 7, 1879. Belva Ann Lockwood was the first woman admitted to the U.S. Supreme Court bar.

In addition to paving the way for female lawyers, she started another legal trend: use of the tricycle. In order to get from her home and office to the courts and clients, she rode an adult tricycle. The head of the law firm eventually bought the tricycle from Belva, noting how quickly the attorneys who used them were getting work done. An apprentice at the same law firm later would be Emma Gillett who founded the Washington School of Law.

Belva's efforts opened the doors to other female lawyers, including the founders of the Washington School of Law and its youngest graduate, Pauline Floyd. At the age of eighty-five, a successful lawyer for many years, Belva said, "Suffrage is no longer an issue. It is an accomplished fact."

A Bored Miss America

For many women today, beauty pageants are a step back from the work of Belva Lockwood and those fighting for the equality of women. Some argue it's a chance for scholarship and philanthropy, while others say that it is demeaning. Margaret Gorman, a D.C. native, said that the pageant was "boring," which doesn't seem like a comment of interest—except that Margaret was the first Miss America.

The *Washington Herald* ran a contest in 1921 featuring thousands of photographs from local beauties. Margaret's Georgetown family sent in one of the rising junior at Western High. Among the finalists, Margaret was promenaded around town so that the public could learn more about her. It was essentially a popularity contest, and she won. She was athletic and outgoing and was named "Miss Washington, D.C."

As the representative of the district, Margaret was sent to Atlantic City for the Second Annual Atlantic City Pageant that September. The pageant was part of a ploy by boardwalk hotel and casino owners to extend the tourist season past Labor Day. With other representatives, Margaret competed in the Inter-City Beauties contest. This was another popularity contest in which judges, who rated her afternoon attire, and the public, based on a chance to talk with the contestants, shared an equal say in the vote. Margaret was awarded the amateur prize.

Left: Miss Washington at the 1921 Atlantic City beauty competition in the bathing suit portion—how times have changed! *Library of Congress Prints and Photographs Collection.*

Below: Margaret Gorman (Miss America) at the Atlantic City Carnival in 1922, wearing a green chiffon dress that she kept for the rest of her life. *Library of Congress Prints and Photographs Collection.*

To continue the public's enjoyment, there was a Bather's Revue—what we would call the swimsuit portion, but with much more swimsuit! There was one portion for local women and even tourists, in which over two hundred women competed, and another portion for professional models and actresses. Margaret won the grand prize, bringing home the two titles of "Inter-City Beauty, Amateur" and the "Most Beautiful Bathing Girl in America."

Never thinking too much of the whole thing, Margaret returned to D.C. to complete her junior year in high school. For the next summer and the third Atlantic City pageant, she was to return and defend her titles. However, she was not Miss Washington, D.C., since someone else had been chosen from a new crop of photos at the *Washington Herald*, so the pageant officials weren't sure what to call her. Since the "Most Beautiful Bathing Girl, Inter-City Beauty Amateur in America" was a rather lengthy title, they just went with "Miss America." This was the first time it was used and has been a staple of September prime time TV ever since.

It seemed Margaret could not have cared less. She used her Inter-City Beauty silver urn as a flower vase. She did keep the lime green chiffon dress she wore as Miss America until old age, hanging it in her closet. But when asked if she would ever compete again, she replied, "Oh, never in my life!"

Angel of the Battlefield

On Seventh Street Northwest in downtown Washington, D.C., there is a brick building right next to a Starbucks. For many years until the 1990s, it was a shoe store on the ground floor with office space on the second. The third floor had not been used in decades and was essentially blocked off. These antebellum buildings in city center were falling into disrepair, and the General Services Administration (GSA), which owned the buildings, decided the best thing to do was tear them down.

Prior to leaving for the Thanksgiving break, GSA carpenter Robert Lyons was inspecting the building to ensure that it was indeed empty before the demolition began. Whether it was luck, fate or the spirit of someone long past, Lyons remained in the upper floor, long cordoned off, hearing noises and evidence of a person who could not be found. With what felt like a tap on the shoulder, he turned and saw the corner of an old envelope peeking out through the floorboards above him. He climbed an old wooden ladder,

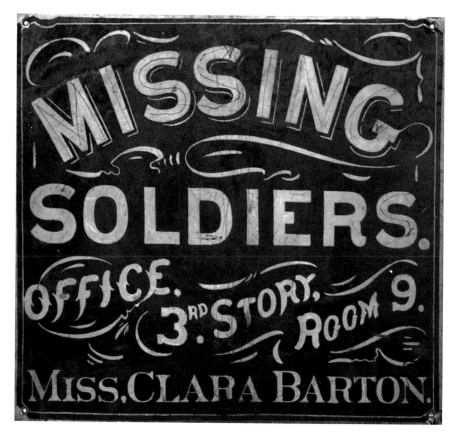

Clara Barton's Missing Soldiers Office sign from her Seventh Street boardinghouse. *U.S. General Services Administration.*

and there he found a metal sign that read: "Missing Soldiers Office 3rd Story Room 9 Miss Clara Barton."

The upstairs had previously been a boardinghouse for those temporarily residing in the city but had not been occupied since 1911. It was then that its last tenant, Edward Shaw, left the building on Seventh Street. He was a colleague of Clara's and maintained the flat and office space after she left on her European travels.

A figure as well known to history as Clara Barton and the location of one of her most important acts in the Civil War was nearly lost. The address on the door says 437½ Seventh Street Northwest, but the address on the letter that began this historical preservation said 488½. The street addresses had changed in the late nineteenth century, so when records indicated 488 as

the address of Clara's office, no one remembered that the building was still standing under a different address.

What seemed to be the attic of this old pre–Civil War building contained a treasure-trove of artifacts—newspapers, records and old socks covered in blood with the footprints of wounded soldiers still found in them. Untouched by time, the rooms are filled with the spirit of the Angel of the Battlefield.

Clara Barton is remembered first and foremost as a nurse during the Civil War—interesting, since she was never actually employed as a nurse. Her time in D.C. started prior to her efforts in support of the troops. Clara had created the first public school in New Jersey by offering to teach less affluent students for free if the city provided a building. Put aside from that school in favor of a male principal, Clara came to Washington, D.C. Even she stated that the reasons for deciding on this location were not clear, but she was always independent and did not want to rely on her family.

Upon arriving in 1855 in Washington, she was hired by Charles Mason, superintendent of the Patent Office. Though he originally had planned on employing her as a governess, he found her to be better suited to an office position as his clerk. Her task was to monitor the other clerks in the Patent Office to ensure their efficiency and that they were not reselling patents for personal gain.

To be employed in the federal government as a woman was rare but not unheard of. However, Clara might be the first female federal employee to earn the same salary as her male coworkers. Despite her gender, she earned $1,400 a year, the same as the other clerks.

However, this was the 1850s, and society and the government had yet to accept a female workforce. Despite the support of her employer to keep her on as a clerk, Clara's position was changed to copyist—a position that was considered more suitable for a woman. She received ten cents for every one hundred words copied. Clara's original role as a clerk caused so much disconcert in the government that all female copyists, including Clara, were sent out of the office to work from home. They would pick up their work at the Patent Office in the morning, copy it at home and return it in the afternoon. Eventually, Clara needn't come in at all. Her job as copyist was eliminated outright.

For three years, she left D.C. to live in Massachusetts, but with the election of Abraham Lincoln, Clara returned. And then the Civil War began.

A week after shots were fired at Fort Sumter, the pro-Confederate residents in the still Union city of Baltimore attacked the Sixth Massachusetts Infantry on their way to defend D.C. Many of these soldiers were Clara's former

students. They arrived broken and bloody with their belongings lost or destroyed into a city that was not prepared for the desolate and wounded. Clara found them quartered in the Senate chambers of the Capitol, being hastily cared for with whatever materials were available.

Distraught at seeing boys she knew personally in such dire straits, Clara began to organize relief. This was the start of years of assistance to the troops and a legacy still remembered today. She advertised in newspapers at home and sent word out to friends and family, and the support of goods came flooding in.

As the battles commenced just outside the city, Clara was there to help the wounded Federal troops and replenish their beleaguered supplies. Ladies' relief organizations were not uncommon at the time, as it was one of the few ways a woman in the mid-nineteenth century could support the war effort.

What set Clara apart is that she didn't just donate a pair of socks that she darned or encourage other women to do the same. She sought out from any and everyone the supplies needed, even detailing to communities what to send and how to best pack them for the journey to D.C. She gathered, collected, organized and then distributed relief in a time when the government didn't have the resources to do the same. And she did it on the battlefield.

In the autumn of 1862, Clara had three warehouses of stores and supplies but was not sure what to do with them. Along with many other women with baskets of goods and in search of lost loved ones, she went to Colonel Daniel Rucker at the quartermaster's office in D.C. Overwhelmed and exhausted, when Colonel Rucker asked what she was in need of, she broke down into tears, saying that she wanted to go to the front. Just like everyone else, he told her that she wouldn't be able to find whomever she was looking for and the front was no place for a lady, especially as a battle was thought to begin soon. Clara wasn't looking for any one person; she was looking for someone to take the three warehouses' worth of supplies she had collected.

Rucker immediately ordered six wagons, men to load the goods and a pass for Clara to get through the lines. Clara was not the first woman to use the sympathy that tears could bring to weaken the will of a hardened man, and this wouldn't be her only time using this womanly weapon. She also never seemed to think it was something for which she needed to apologize.

With her pass and supply-laden wagons, Clara headed to Fredericksburg, Virginia, where the men greeted her enthusiastically. They were in need but had not recently seen battle; this was months before the horror that would come to that small town.

If aiding these men brought any sense of accomplishment to Clara, it was soon overshadowed by grief. Having returned to D.C., she heard over the telegrams of the Battle of Cedar Mountain in Virginia. Not waiting for new passes, just using the ones she had already received, Clara's first foray to the front was in Culpeper, Virginia. She spent two days there as a nurse with the wounded and at the Confederate prisoners' hospital.

For the next two years, Clara went back and forth between Washington, D.C., where she gathered supplies and petitioned for more, and outside the city at the sites of some of the war's most bloody battles. A true asset to the Union, Clara was a tolerated, even welcomed, sight, but she was not an official agent of the government. Without having to follow orders or regulations, Clara could do as she pleased, and what she pleased was often what was best for the soldiers. She would often know where the next battle would take place, and before the first shot was fired, she would be camping on the battlefield. Clara did not want to wait at the field hospital, as even that was too far from the men who needed her aid. She filled the gap, treating the wounded as they were coming from the battle.

In September 1862, she was with the Army of the Potomac at the Battle of Antietam. As she was giving a fallen soldier a drink of water, a bullet caught her sleeve, tearing through, and killed the man she was nursing. She had no medical training and was not a certified nurse during her time in the field, but necessity is a good teacher. On the field, with no surgeons in sight, Clara surgically removed a bullet fragment from a wounded soldier with her penknife. Exhausted, she recorded tidbits and thoughts, documenting what she saw and how she felt. "Twisted bodies, splintered bones, raw flesh, burning fevers, and fetid air...hot...am tired."

Various sources claim Victoria Woodhall or Elizabeth Cady Stanton as the first woman to testify before Congress, in 1871 and 1869, respectively. Perhaps there is a qualifier or some distinction that makes this true, but Clara Barton did it in 1866 after her visit to Confederate prison Camp Sumter, known today as Andersonville, to report on the conditions she found.

With the war at its end, many families expected their loved ones to come home soon—and often they did not. The Office of Correspondence with Friends of the Missing Men of the United States Army was established under the authority of President Abraham Lincoln a month before he was assassinated. Clara began by opening her rooms in the Seventh Street boardinghouse and hiring clerks to run the search for lost soldiers.

In the third-floor rooms she rented, Clara slept and worked. As she continued to receive materials, she eventually cordoned off her sleeping

space to a smaller section to create a storage area for supplies. Clara's role in finding missing soldiers was both administrative and detective.

In newspapers around the country, Clara published her message:

> *Soldiers and friends of soldiers—this roll is composed entirely of names of soldiers who have been killed in battle, died in Southern prisons, or otherwise lost in the service, and whose fate is unknown to their friends…They have been your comrades on march, picket or raid, or in battle, hospital or prison; and falling there the fact and manner of their death may be known only to you…Please examine these rolls and if you have facts relating to any one herein named communicate them to me by letter with your full address that the information may be immediately forwarded to their inquiring friends.*

And from here, she listed the hundreds and thousands of names, divided by state.

She worked tirelessly until 1869, when she closed the office, having answered 63,182 letters. With her assistance, the fate of twenty-two thousand men had been identified.

Clara Barton, the Angel of the Battlefield, is mostly known for her post–Civil War relief efforts in founding the American Red Cross. Before she did this, however, she was a Patent Office clerk, war relief organizer, frontline nurse and finder of missing soldiers. All of this she did in a time when women were thought too weak-willed and incompetent to do the same work as men and stomach the gory scenes of battle. At a time when women needed men's assistance, Clara did it without them. She visited and befriended married men without impropriety in the name of business. In the mid-nineteenth century, women were not in business, so to call on a man, a married one especially, would have been seen as a social visit. Clara continued to the offices and battlefield without a male escort, which would have typically seen her labeled as a tart, but her reputation remained unscathed. Clara was not wild or scandalous in her actions, except by the standards of the times, which makes her all the more a pioneer.

CHAPTER 5

DUPLICITOUS DAMES

In times of war, fathers, sons and brothers could fight for what they believed in, regardless of on what side that might be. In the Union capital of Washington, many Southern families sent their men to fight with the Confederacy. Women didn't have that same option, unless they wanted to dress up like men. Women did, however, have the advantage of their womanly ways. From the Civil War to the Cold War, men did not expect that a woman's flirtations would be anything more than simple attraction. In reality, powerful men had more reason to suspect a pretty girl's advances, as she might not be after his wallet but maybe after his briefcase.

BETTY PACK AKA CYNTHIA

"Ashamed? Not in the least. My superiors told me that the results of my work saved thousands of British and American lives…It involved me in situations from which 'respectable' women draw back—but mine was total commitment. Wars are not won by respectable methods."

The situations Betty Thorpe Pack was referring to involved using her womanly ways to elicit information from sources who, outside of pillow talk, might not have shared these deepest, darkest secrets. Amy Elizabeth Thorpe, who went by "Betty," was an all-American beauty from Minnesota born to a U.S. Marine Corps officer and the daughter of a senator.

Growing up, she traveled the world. By the age of nine, she had lived in two states and in Cuba and Hawaii, which wasn't a state yet. Her classmates gossiped about the rebellious girl who was once expelled for setting a bad example. As a young teenager, she had befriended a middle-aged Italian diplomat and would meet him for tea. Making her debut in Washington, D.C., she befriended older, well-placed gentlemen who taught her the ways of the world—at least socially, if not in other ways, though rumor had it she lost her virginity at fourteen. Betty's association with many older diplomatic figures should have ended with her marriage to Arthur Pack, an undersecretary at the British Embassy.

The marriage did not seem to be a good match, perhaps leading to her acceptance of her future role as a seductive spy. Albert was nineteen years older than Betty and distant, lacking the passion for life that she had. It was only five months after the wedding that their son was born. He was born abroad during a very long honeymoon to hide the premarital pregnancy. He was given to a foster family before the Packs returned to Washington. Even if they were unhappy, Betty went to Europe when Albert was transferred, and it was here that she began her time as a spy for her adopted country through marriage, England.

Her first foray was during the Spanish Civil War while her husband was stationed in Madrid. Here she assisted in the evacuation of the British Embassy in northern Spain, brought aid to Franco's forces from the Red Cross and helped five rebels to safety. It was also here that Betty started taking lovers. When the loyalists were holding one of her paramours captive in Valencia, Betty convinced another lover to share whatever information he had. Eventually, she was able to commandeer the release of her former beau and sixteen others.

The Packs were eventually transferred to Poland, where Betty found a new lover in a married Polish official. It is said that she was able to learn information about the Poles' efforts to decode the German Enigma machine from Michel Lubienski. While everyone agrees that this information on how the machine worked and breaking its code was essential in the coming World War II, not everyone agrees that Betty was the reason the British learned of it.

Having moved yet again, Betty and Arthur were in Chile when World War II broke out. She was writing for Spanish and English newspapers and compiling names of Nazi sympathizers in Chile for the British government.

With the war in full throttle in Europe, Betty would serve the British intelligence community better outside of Chile and moved, without her husband, to Washington by way of New York City. She was given the code name

Cynthia and was posed in D.C. as an American journalist. Her first assignment involved her old tea partner, the Italian diplomat. Again, sources differ on the effect of the information she received, as well as how she received it. The general consensus at the time was that she seduced her old friend Alberto Lais, the naval attaché to the Italian Embassy, to get the Italian naval ciphers. Years after his death, his heirs sued authors describing the affair for libel and won. However the information was received, whether with Lais's assistance and/or through sexual means, these codes helped the Allies in achieving victories in the Mediterranean.

With the Italian naval codes successfully under her belt, Cynthia's next mission was to gain access to those of Vichy France. This time, her mark

The Enigma machine, much like the one spy "Cynthia" (Betty Thorpe Pack) helped decode. *CIA Photo Archive.*

was the press attaché, Charles Brousse. She had to keep her cover as an American journalist thanks to the anti-British sentiment in Vichy. It was not a complete lie, as she was American; it's just that she was working for the British. In addition, the Office of Strategic Services (OSS), the precursor to the CIA, would assist the mission.

Brousse was married but, like many men before him, could not resist Betty's charm and beauty. He passed along information from the Vichy government to his mistress, thinking he had turned on his government to work for the Americans. When Betty brought up the naval ciphers, there was nothing she could do to seduce the information out of him—he didn't have it. The codes were locked away in a safe and guarded by a night watchman and his guard dog. Betty wasn't going to let that stop her.

Brousse paid off the night watchman under the pretense of allowing him and his mistress a place to hide their affair from prying eyes. If he

was telling his wife that he was working late at the office, he wanted to be able to answer the phone should she call. After a few nights of playing the hidden couple, Brousse and Betty drugged the guard and his dog. Having gained the assistance of an OSS professional known only as the "Georgia Cracker," they were able to break into the safe. All that work was for naught, as they couldn't photograph the codes once they had broken into the safe at 4:00 a.m. There would not be enough time to get the books back to their hotel to be photographed and returned before the cleaning crews came in the morning. This was 1942, and iPhone cameras had yet to be invented. The professional code breaker, who had been recruited straight from prison, gave Betty the code: 4 left 5; 3 right 20; 2 left 95; 1 right 2; stop.

The next effort was just as unsuccessful. The Georgia Cracker was unavailable, and Betty could not get the old safe to open, even with the code. The third time was a charm, however, and with the help of the Cracker again, they were able to break into the safe, steal the books for a few hours and copy the ciphers. They would have been caught if not for Betty's women's intuition. Sensing something had gone awry with the night watchman, Betty undressed and forced Brousse to do the same. The guard was quite embarrassed when he walked in on the two lovers, obviously in the midst of a tryst and not trying to steal anything. Betty had a hint that something was off when she and Brousse entered the French chancery earlier that night. Two unfamiliar cars were parked nearby. Just like today, the OSS's CIA-esque operations were performed under the radar of the FBI. Betty was under suspicion of pro-Nazi activities by the FBI and often felt they were monitoring her. Once the night watchman saw in the flesh that the affair was no lie, those two cars drove off.

Despite the many pillows on which Betty had late-night conversations, her affair with Brousse was obviously more than just the act of a spy. She had moved out of her house in Georgetown to where he was staying at the Wardham Hotel in northwest D.C., though this wasn't only to be closer to her lover. With the FBI keeping watch on her actions, living in the same hotel as Brousse would limit their ability to track her movements to him. The Wardham Hotel is also where her OSS liaison, Ellery Huntington, known to her as Mr. Hunter, was staying with his surveillance and photographic equipment. What most proves her true feelings for Brousse, though, are her actions after the mission's success. Arthur Pack had remained her husband in the eyes of the law, though their relationship was platonic. After the war, he committed suicide. When Brousse divorced his wife, he married Betty.

They moved to an actual castle in France and lived out the last few years of their lives. Betty died of throat cancer in 1963. A few months prior to her death, her old friend Ellery stopped by for a visit. He still called her Cynthia.

Rebel Rose, the Queen of Confederate Spies

The nature of being a successful spy includes never getting caught. Many spies of history are known because they were either caught or acknowledged in some way. At the time of your work, however, you weren't supposed to be known. In this way, the most famous female spy in Civil War D.C. was actually pretty bad at it. Rose O'Neal Greenhow was good at getting information—very good at it. From there, however, it was less skill and more luck.

Rose was born in Maryland but orphaned at a young age, so she and her sister moved in with an aunt in Washington, D.C. The aunt ran a boardinghouse out of the Old Capitol Building, where the Supreme Court now stands. Living here, Rose became accustomed to social life among the prominent politicians who were staying in the boardinghouse.

She became a well-known beauty in Washington society in the 1830s. She was well educated, intelligent and a great conversationalist. Though he was many years her senior, she wed a Virginia doctor, Robert Greenhow. This match was accepted with pleasure in Washington society. Even Dolley Madison gave her approval. This was a much-welcomed benefit to Rose, since before her marriage, the women about town often snubbed her because of her unimportant upbringing. Men always seemed to give her another chance, though.

The Greenhows moved to Mexico and California for a few years, but Rose eventually returned to D.C. with the children. As tensions between the North and South escalated, Rose's husband died. As a widow, she was able to focus her support on the Southern states. At her home at 398 Sixteenth Street Northwest, she would have frequent visitors of the male persuasion to the point that neighbors noticed. One of these visitors was President Buchanan, a good friend, though no evidence remains of a more intimate relationship. James Buchanan was the only bachelor president. It was at Rose's insistence that he even became president, a position for which he did not necessarily strive. His main opponent was John Fremont, whose election would elevate Rose's social rival and John's wife, Jessie Fremont, to the most coveted role in social Washington. With Buchanan as head of the nation, Rose maintained

her status. She remained then well ensconced in society and friends with many men in positions of power within the government.

Rose let it be known that she was sympathetic to the Confederate cause, which seemed to have little effect on her friendships with men who were not. Shortly after the start of the war, U.S. Army quartermaster Thomas Jordan sought out Rose to recruit her into his network of spies in Washington. She told him she would do *anything* to aid the Confederacy. He gave her a twenty-six-symbol cipher used to encode secret messages. She spent hours practicing the symbols, but rather than memorize this highly valuable information, Rose kept a written copy of it. This could prove deadly should the wrong person get ahold of it and send false messages to the Confederates or use it against Rose on the charge of treason.

With Jordan's recruitment complete, he left the U.S. Army and joined the ranks of the Confederates. He remained in touch with Rose as her handler with the Confederate Secret Service and continued to relay messages to and from her.

Rose was most accomplished at using her connections in the government to obtain sensitive information. Henry Wilson, senator from Massachusetts, is considered to have been one of her most important sources. As a member on the Military Affairs Committee, much of the information on the number of guns and artillery and on Washington's defenses likely came from him. A collection of thirteen love letters sent to Rose is thought to be from him, though some historians believe they are from his secretary, Horace White. These letters were signed with only initials and could be either man. Though they might have indicated the source of her information, Wilson was never looked into by the federal forces. Inquiries to the Senate secretary were kept hidden and remain in the archives to this day.

Rose had access to Union troop movements and plans. In fact, she had an actual copy of Union general McDowell's plans for the attack on Manassas, minutes from meetings and, later, private conversations of Union major general McClellan. At the outset of the war, she passed along a message to Confederate general P.G.T. Beauregard through one of her other feminine associates, Bettie Duval. The young sixteen-year-old dressed as a milkmaid as she made her way through the Union lines without suspicion on her milk cart. As soon as she made it to Virginia, Bettie changed into a riding habit and galloped to find Beauregard, revealing the message she had hidden in a silk pouch tied in her hair in a bun at the base of her neck. The message let the Confederate forces know that the Union was planning a surprise attack at Manassas in a few days. This warning gave Beauregard sufficient time

to reinforce his troops and send the Northern soldiers back to D.C. broken and bloodied. For her effort in this successful battle, Confederate president Jefferson Davis gave Rose his gratitude.

Rose was not at it for long when Allen Pinkerton, head of the newly formed Intelligence Service, began to crack down on female Confederate sympathizers whom he suspected of spying. An anonymous source let it be known that Rose was seducing information from Union men to share with the South. He had agents follow Rose and guard her house, though Rose was aware of this thanks to an informant passing her on the street. Before the agents could arrest her, she gave word to co-conspirators that she was about to be arrested, and she swallowed a note she was carrying so as not to be caught with it.

Agents searched her house extensively but had neither the time nor manpower to do so effectively. They found notes about military operations and War Department orders. In the kitchen was evidence of letters that had been burned, but they could not be used to incriminate Rose.

Rose's luck continued when her friend Lillie Mackall came to visit. Lillie had been a confidante and somewhat of a courier for Rose, but most of all, Lillie was observant. She remembered that they had not yet sent the letters meant for Jordan, which were still in the house. Rose claimed in her memoirs that she would have burned down the entire house if there wasn't a way to secure those letters from falling into Union possession. Luckily, there was a way. Since no female guards had yet arrived, she was allowed upstairs alone to change clothes, at which time she got rid of the evidence.

The guards later found the well-stocked liquor cabinet and helped themselves to the stores. Rose and Lillie took this time to gather a few more items that could be used against them. Lillie would eventually be kicked out of the house. Officials thought, rightly, that she was sneaking messages. Before she left, she noticed a blotter, still wet with the visible message to Jordan, and destroyed it.

Rose and her daughter were kept under house arrest. More women suspected of spying for the Confederacy were brought in, including the Phillipses and a few suspected couriers. The newspapers dubbed the house "Fort Greenhow." But just as Rose had drawings of the Union fortifications, she knew her way around this "fort" as well. It was her home, after all. Though her mail was closely read, her windows were boarded shut and she was kept from going outside or near the front door, still the messages came and went.

One of them was a letter to Secretary of State William Seward demanding to know why she was subject to this ill treatment. Wisely, she sent a copy to a

Rose O'Neal Greenhow and her daughter, Little Rose, while under house arrest at her home in Washington, D.C., during the Civil War. *Library of Congress Prints and Photographs Collection.*

Richmond newspaper to have it published. Though the plan was to keep her arrest quiet, there was nothing quiet about Rose, and the plan backfired. She became an interest piece for both sides.

When officials could no longer trust her at the house, she was moved to the Old Capitol Prison. Ironically, this was the old boardinghouse in which she grew up and learned how to converse with congressmen. Her young daughter, Little Rose, and herself lived in a small room with a table and chairs and a lice-ridden straw mattress.

When the threat of a trial was brought against Rose, she only laughed and said that she would have much to reveal. This scared the government men straight, for if she were brought to court, surely she would have some

information about each of them to share. Her ability to determine who was worth knowing and to elicit information from and about them served her well both as a spy and a prisoner.

Eventually, the government decided that what was best for both the individual reputations of its members and the Union as a whole was to exile Rose. She and her daughter were sent south. Rose arrived a heroine for the Confederate cause.

Exiled South

"A sojourn of ten years in the city of Washington had made me part and parcel of the Southern society, all my sympathies, interests, and affections being with them. Born in Charleston, South Carolina, of course I could entertain no very great admiration for our Northern brethren."

Born in South Carolina and living a decade in Washington, Eugenia Phillips was the wife of a former Alabama congressman turned lawyer. Her husband, Philip Phillips, and his family remained in the city as the Southern states seceded because he did not support the breaking up of the Union. Though Eugenia, as a good Southern wife, would stay with her husband, it did not mean she would agree with him. This was made evident by her outspoken opinions on the entire matter.

It is a bit confusing to think of Washington as Southern society when it was the capital of the Northern states during the Civil War. The distinction remains today that separates the government in D.C. and the society of D.C. There were many Southern families living in the city at the outbreak of the war, leading to many Southern sympathizers who would be suspected of providing information to the Confederacy.

History suspects Eugenia of being a Confederate spy, perhaps part of Rose Greenhow's infamous spy ring. If she was a spy, she was good at it, and there was little evidence to prove it. The Union government suspected it as well, but in a time of war, evidence wasn't needed.

In August 1861, the Phillips home was filled with soldiers as they placed the family under arrest. With her sister and a family friend visiting, crying children and soldiers rushing through, the house turned chaotic. Eugenia took the confusion to whisper a message to one of her servants: "The box in my washstand. Destroy it." Here she had kept her letters, which may not have in reality been treasonous but held some comments that could have been considered such at the

Eugenia Phillips, exiled for being a Confederate spy, was kept at the home of Rose Greenhow in a women's prison of sorts during the Civil War. *Library of Congress Prints and Photographs Collection.*

time. These letters to and from friends and family declared her opposition to black Republicans and contained callous comments about President Lincoln. The servant was able to snatch the letters before they were found but not able to destroy them. Eugenia saw that they had been stuffed in the bosom of the woman's dress and could only hope that the Federal soldiers had the respect not to search there, though she had heard stories otherwise.

The soldiers rummaged through the house. They shook the pages of every book, opened every drawer and even looked through her purse. Upon finding a memo book, they hoped to find coded messages to the Confederacy but only found a shopping list. Eugenia did not help herself or her family and mocked them through the entire venture. As they read her list, she exclaimed over their shoulders in fake surprise, "'Four yards of tape'—treason! 'Five pieces of ribbon'—important dispatch!"

As the soldiers moved the family to the back rooms, the Phillipses were able to slip a small note out the front window. A passing friend picked it up but was spotted by the Federal forces. They thought they had caught the spies in the act. Forcing him to show the note, all they found was the simple truth: "We are all arrested."

Philip Phillips was released, but his wife and two daughters were imprisoned. On what charges or evidence was never satisfactorily explained to Eugenia, and she took great pains to express her unhappiness. The three women were brought to Rose Greenhow's house and confined to quarters in the attic.

They spent the next three weeks confined to their rooms with the exception of sullen meals downstairs. They were given little comfort and treated with

much indignity. Eugenia made it just as uncomfortable for her guards as they had made it on her. A watch was kept on these dinners to monitor their conversations, so the ladies spoke in French. They believed, and were likely correct in the assumption, that the soldier did not speak the language. Of course, Eugenia stated that it had been years since she studied the language, so much of what she said was nonsense, but she felt it had served its purpose in annoying the guard.

Philip was able to obtain their release with the help of family friend Edwin Stanton. Eugenia and her daughters were not declared innocent and allowed to continue their life in Washington society, however. Their release was under the condition that Philip take his wife south. She was essentially exiled to the Confederacy—not a bad place to go for a Southern sympathizer.

Eugenia got the last laugh. The family was escorted out of the city on a cold day, and as they left, their bags were searched to make sure they did not take anything with them that could be used to the Confederacy's advantage. Eugenia had once heard somewhere that newspaper was a great conductor of body heat, and underneath her clothes she had wrapped herself in Union newspapers and maps in order to keep warm. The soldiers were none the wiser, and when she made it to Richmond, Eugenia found no need for the continued warmth and passed along the papers to President Jefferson Davis of the Confederacy.

CHAPTER 6
SCANDALOUS SOCIALITES

A t the turn of the nineteenth century along the East Coast, to be considered one of the elite your great-great-grandfather had to have fought in the Revolutionary War, your family had to have buildings named after it and you had to have been rich your entire life. In Boston, your ancestors were minutemen, in Philadelphia they signed the Declaration and in Plymouth, they were on the *Mayflower*. Washington, D.C., was barely a century old itself and was the home to the *nouveaux riche*. Self-made millionaires who had no glamorous family ties were welcomed in the city where all you needed was wealth. A line from *Advise and Consent*, thought to be written about D.C. socialite Perle Mesta, could be applied to many: "Any bitch with a million dollars, a big house and a good caterer can be a social success in Washington."

As these men came in droves to build mansions in Dupont Circle and make friends with the powerful, their wives and daughters had to climb the social ladder themselves. In the days when a good party made you somebody in this town and business deals were done over steak dinners, it was usually the women climbing the ladder and dragging the men up with them.

MARY'S CASTLE

Mary Foote came from New York City in order to meet the prominent single men in the capital. She succeeded in marrying a senator from

Missouri, John Brooks Henderson, known for co-sponsoring the Thirteenth Amendment banning slavery. Her social rise began when they returned from a few years in Missouri in 1887. The Hendersons purchased land and eventually built, for all intents and purposes, a castle at the corner of Boundary Road, what we now call Florida Avenue, and Sixteenth Street Northwest. In fact, it was called Boundary Castle. The home has long since been torn down, but the large brick wall that surrounded it still remains, guarding the newly built row houses.

Though they shared a road with the White House, this area of town wasn't necessarily the most fashionable. Instead of moving to the best part of town, Mary decided to bring the best part of town to her. After her magnificent home was completed and invites to her parties were highly sought after, she used her social stature to renovate the northern part of Sixteenth Street.

Mary started at the top. Her first effort was to bring the president's home closer to her. At the end of the 1800s, there was thought of building a new executive mansion because the stale swampy air near the National Mall was not healthy for the president and his family. Mary had plans drawn up for a new home across the street from her castle, up the hill where the air was fresher. Two plans submitted within two years were both politely ignored for they were far too pretentious in design.

When that failed, she purchased much of the land along Sixteenth Street near her home and built various styles of mansions to be rented out to the rich and famous in the city. These would eventually be occupied by the embassies of Denmark, Sweden, Poland and France. She succeeded in bringing the international society to her.

Mary's soirées were at the top of the social calendar, as much for the entertainment as for their uniqueness. Before she moved to D.C., she was an accomplished writer and continued her work on healthy living. She was a strict vegetarian, and all her dinner parties served mock meats and fish. The menus even had calorie counts. She also avoided alcohol. This was something her husband did not support, and he had an extensive wine cellar. A 1906 newspaper reported on the day that Mary decided to dispose of the collection. With the help of the Independent Order of Rechabites, of which her butler was a member, she threw her husband's wine collection into the front yard. When the bottles were smashed onto a rock in the yard, a stream of wine cascaded down the gutters of Sixteenth Street. Nearby residents stood waiting with empty cans and spoons to scoop it up.

Mary's extravagance was never fully realized. She had grand plans that never panned out. She presented Meridian Hill as the ideal place for the

Lincoln Memorial when it was being debated. She had Sixteenth Street renamed "Avenue of the Presidents" with the plan to line it with presidential busts. The busts never appeared, and the street was changed back to Sixteenth Street a year later.

In her final days, Mary's granddaughter was trying to have her sent to a home. Mary countered by saying that the granddaughter was illegitimate and was not to be named heir to the estate. Mary's story was that her son was so pressured into producing a granddaughter that he and his wife faked the entire thing. His wife wore pillows under her dresses, and on the day of the "birth," all the servants were sent away and a baby was smuggled into the residence to act as the newborn. With the right to inherit gone, Mary's estate was safe and the granddaughter had no say in the plans. When Mary died in 1931, she left most of the estate to her secretary, who in turn gave most of it to the granddaughter.

Boundary Castle was sold a few years later and became a tennis and swimming club with a bar inside. The home of a teetotaling woman became such a noisy and drunken institution on the block that wealthy neighbors bought it to tear it down. The building, but not the surrounding wall, was razed in 1949.

Mary's most lasting legacy remains to this day, across from the site of her destroyed castle. Meridian Hill Park used to be a neighborhood full of single-story frame houses. This area was outside the original city limits and had been settled during the Civil War by black Americans. More than fifty years later, this Meridian Hill neighborhood was densely occupied, and most of the families owned their houses. They were no match for Mary and Congress, and when the idea for Meridian Hill Park was approved, their houses were torn down. Mary felt no remorse and even bragged about pulling down the shacks. They were, after all, not part of her plan to bring the best to her.

Hostess with the Mostess

Even through her days of improving the outskirts of the city, and despite her lack of alcohol, Mary remained one of the more popular hostesses in early twentieth-century Washington. The torch would be passed to Perle Mesta, but not for long.

Perle Mesta was a western girl from Oklahoma who, through marriage, became the sole heir to a multimillion-dollar steel fortune. Before her rise in

D.C. society, she was an active participant in Alice Paul and Belva Lockwood's National Woman's Party. To her advantage, she changed political parties in the 1940s and supported Truman. When he won, he rewarded her support and made her ambassador to Luxembourg. This was good and bad for her social career.

She was by no means beautiful and was said to have bullied people into attending her functions rather than simply inviting them. However, an invitation to her event meant you had made it in the Washington social circle. Her parties were large and frequent, crammed with as many people in power as could fit into her ballroom. The supply of liquor was never-ending, leading guests to call her the "hostess with the mostess." However, with her absence to Europe to take her position as ambassador, other women were able to make the climb more freely to steal her spot as the reigning hostess.

Gwendolyn Cafritz was an attractive Hungarian immigrant with much more charm than Perle. Gwen claimed that she used her address book to invite her guests, while Perle used the telephone book. In reality, both women were very well connected. With Perle gone, the newcomer staked her claim. Her parties were political soirées covered by *Life* and *Time* magazines. Gwen had supported the Republicans during the Truman campaign and, after he won, had to woo the Democrats. This she easily did. The day after Perle left, the Cafritzes threw a party to celebrate their twentieth anniversary, which was obviously a chance to win back social favor. The steak dinner was the perfect ploy for the many bachelor congressmen.

Gwen wasn't Perle's only adversary. American-born British socialite Lady Astor had an all-out throw-down fight with Perle, which, in the 1940s upper class, meant a war fought with catty quotes in the social section of the newspapers. Lady Astor was speaking at the Women's National Farm and Garden Association in 1948 demeaning American women's interest in "liquor, clothes, and brassier ads." Insulted, Perle stood up and left in the middle of Lady Astor's talk.

From here, the two women went back and forth to newspaper reporters about their feud. Perle was quoted as saying, "Our women are interested in uplift, but it is uplift of their minds and culture, and not their bosoms." Lady Astor called Perle "silly" and a "social climber," and the newspapers loved it.

Perle returned a few months after her posting to Luxembourg to report to the State Department, though most believed the visit was to remind everyone of her social status. With Gwen and Perle clawing at the top, it proved difficult for anyone else throwing a party. You could not invite just one, but you also could not expect them both to be anywhere near each other.

In the eyes of history, Perle remained the "hostess with the mostess." History is written by the victors, after all, or, if not written by the victors, then certainly about them. The Broadway musical *Call Me Madame* is based on Perle, making her the socialite most remembered, at least by the certain sect of the American population that cares about socialites and musicals.

Marjorie's Many Husbands

At the time, contemporaries weren't sure with which hostess to align. However, there was one person who could get them both to attend the same event: Marjorie Merriweather Post. Marjorie, heiress to the Post/General Mills fortune, was wealthy in money, art and husbands. Her lifestyle was lavish, to the point of excess that many Washingtonians did not approve. Gwen and Perle always accepted her invitations.

Marjorie and her money were entertaining to the blue bloods of the city, but they rarely invited her to their parties. She had five enormous mansions throughout the country and the largest privately owned yacht, so she was more than capable of entertaining herself. Her business continued to improve, and her wealth increased, but she was never quite sure why she wasn't able to keep her husbands.

Her first husband was Edward Close, who would become the grandfather of Glenn Close through his second marriage. Their younger daughter, Eleanor, ended up marrying six times in her life, and the oldest daughter, Adelaide, married three times. This marriage ended in divorce after Marjorie learned the benefits of independent living while Edward was serving in World War I. Their marriage was drifting before the war, however, due to their two very different personalities.

Her second husband was Edward Francis (E.F.) Hutton, whom she described as the love of her life. Their daughter, actress Dina Merrill, would marry three times. This marriage, too, ended in divorce, at the request of Marjorie. A woman requesting and being granted a divorce in the mid-1930s was rare. The only way to legally get a divorce was with proof of adultery. Their intense and deep love was only threatened by the fact that E.F. also loved other women.

Rumors of her husband's affairs abounded, which was not uncommon among her social set. Many of Marjorie's friends had philandering husbands, and she felt sorry for them. They accepted it, but she wasn't going to sit

down and take it. Despite her love of her husband, she could no longer take the insult. On a photograph of herself she had given to E.F., she wrote a small note: "To Ed, your favorite wife at the moment."

Marjorie was going to find proof of the affair she suspected E.F. of having with their live-in maid. She attached barely visible silk threads to the doors between E.F.'s bedroom and the entrance to the maid's room. When that failed, she put a bell under his bed that would ring if the weight on his bed were ever more than his own. However, that also failed to catch him in the act.

Finally, after he had retired for the night one evening, she tied silk threads along his doorway and had talcum powder put on the floor. The next morning, the threads were broken, two sets of footprints were visible on the floor and talcum powder was in the bed. This proved his infidelity, and the divorce was granted.

Her third husband, Joseph Davies, was the American ambassador to the Soviet Union under Stalin. They lived in Russia for one year, acquiring much artwork. Though the purchases the Davieses made were from the government, it is believed that much of the art was confiscated illegally or through brute force during the Stalin regime. The art is still on display at the Hillwood Museum, the old Post mansion turned museum after her death.

When Joseph turned ill in the 1950s, he gradually became more negative. Marjorie believed in the power of positive thinking and could no longer accept Joseph's attitude in her life. They divorced in 1955.

Her fourth marriage to husband Herbert May also ended in divorce. He was a homosexual.

THE OTHER WASHINGTON MONUMENT

Where Perle Mesta and Gwen Cafritz would come together for Marjorie Post's gatherings, one woman disliked all of them. Alice Roosevelt Longworth made it a habit of not really liking anyone, it seemed. Of Marjorie's many husbands, Alice said, "Oh my, I can't possibly keep up with all the husbands' names. I just call her 'Miss Post Toasties' and let it go at that." Where Marjorie threw parties because she enjoyed sharing her wealth, and Gwen enjoyed the conversations, Alice enjoyed inviting sworn enemies and watching them squirm by seating them next to each other. One of her favorite quotes was stitched into a pillow to sit on her settee: "If you can't say something good about someone, sit right here by me."

Alice Roosevelt was the eldest daughter of President Theodore Roosevelt and cousin to FDR and Eleanor. She did not like them, either. Alice was a precocious child and an independent teenager, often being sent to stay with relatives when her father and stepmother could not handle her. Most images of her show her head held high, and her blunt attitude was well known. She, like her father, enjoyed being the center of attention and wanted her opinions known. At one point in the White House, Teddy threatened to throw her out the window if she barreled into the Oval Office one more time espousing her political opinions.

Her president father tried to set some rules. He told Alice not to smoke in the White House, so she climbed up to the roof. She was often found at the racetrack and occasionally danced on the tops of cars. In her handbag, she was said to carry a copy of the Constitution, a snake and a dagger. She was caught by the D.C. police for speeding in a red sports car. This was in a time when most women did not drive at all.

The public adored her, and she continued her relationship with them by offering "tips" to the newspaper about her whereabouts and antics. Her stepmother, Edith Roosevelt, did not have the same desire for a large number of new dresses as Mary Todd Lincoln. It was a time before the first lady was constantly in the public eye, so rather than purchase dress after dress for each occasion, Edith simply reported to the press what she wore at the event. However, her periwinkle blue dress was indeed the very same dress as her sky blue and royal blue dress. She simply had her Alice describe the dresses with different adjectives to give the illusion of a massive wardrobe. It was one of the few times teenage Alice was an aid to her stepmother.

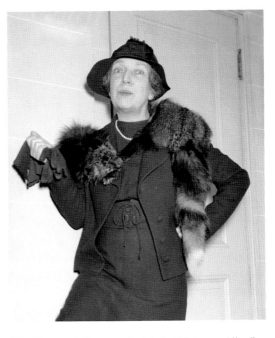

Alice Roosevelt Longworth, labeled "Princess Alice." *Library of Congress Prints and Photographs Collection.*

"Princess Alice," as she was called, married a congressman who was popular with men of all political persuasions and their wives. Nicholas Longworth was a congenial representative from Ohio with a great sense of humor who was able to put up with Alice's theatrics. He was also very wealthy.

Their February 1906 wedding was the social event of the season, with more than one thousand invited guests and even more outside hoping to catch a glimpse. It was very much a royal wedding. The guest list represented American government and royalty from most of the civilized world. Alice wore satin, silk and diamonds, and the gifts were equally as exuberant. In her flashy style, she cut the first slice of the cake with a military sword that she borrowed from a nearby major.

Nicholas Longworth knew what he was getting himself into. He had accompanied her on a lengthy voyage the year before to China, Korea, Japan and the Philippines. As the two were young and unmarried, they were chaperoned by William Howard Taft, then the secretary of war. It was an odd choice for a babysitter, but he was there making secret negotiations with Japan, and Alice was there to distract the nation's press.

As the ship crossed the Pacific, she jumped into the pool with all her clothes on and tried to get Nicholas to join her. When told that was an outrageous act, she simply said it would have only been outrageous if she had taken her clothes off first. She later said of the incident that her clothes were nearly the same as the swimsuits of the time. That wouldn't be the only time that she made a scene fully clothed in the water. Her canoe capsized on a journey in Hawaii, and she took it as a chance to laugh and splash around—all captured on camera by the press.

Though married, Nicholas did not succeed in getting Alice to settle down. She had a well-known and acknowledged affair with Senator William Borah of Idaho. Alice's only daughter, Pauline, was his and not her husband's. In typical Alice fashion, which was essentially just cruel, she joked that she wanted to name the young girl Deborah, as in "de Borah."

Despite her blunt nature and tendency to make jokes at the expense of others, Alice was known to treat everyone the same regardless of their social stature, wealth or race. She lived to be ninety-six years old, having suffered through a broken hip, cancer and emphysema. She was such an important part of both the D.C. social and political scenes that she was called "the other Washington Monument." She disliked Nellie Taft, despite their similarity in ignoring Prohibition, and even put a hex on the incoming first family with a voodoo doll of Nellie buried in the North Lawn. She disliked the Wilsons and the Hardings, as well.

She had tolerated the company of Florence Harding at a poker game attended by her best friend Evalyn Walsh McLean. Alice may have disliked Florence less because of herself and more because she stole her friend Evalyn.

The Curse of the Hope Diamond

Evalyn was not shy about her money or how new it was. Her memoir is entitled *Father Struck It Rich*. When the circus came to town, she was too afraid to let her precious son attend the event, so she bought the circus and had it set up in the yard.

Just as Perle Mesta's state-sponsored journey to Luxembourg inspired a musical, Evalyn's trip to Russia was mentioned in Cole Porter's *Anything Goes*, with lyrics that say, "When Mrs. Ned McLean (God bless her) can get Russian reds to 'yes' her, then I suppose…Anything goes." Evalyn was the daughter of a prospector who did indeed strike it rich. Dinners held while she was growing up were served on gold plates made from gold nuggets from her father's mine. She grew up in a beautiful Massachusetts Avenue mansion that is now the Indonesian Embassy. Eventually, Evalyn married the heir to the *Washington Post* family, Edward McLean.

With both her family and her husband's money, Evalyn dominated the social scene. She threw extravagant parties that were attended by thousands, including diplomats, politicians and celebrities.

One of her many shopping sprees displayed her life of leisure. She was driven around in a chauffeured Rolls Royce, and shopkeepers would bring their goods out to her to choose from. She never had to leave her car. Her most well-known purchase, however, was a very large blue diamond that we know as the Hope Diamond.

There is no hope associated with this stone; it is simply named after one of its previous owners, the Hope family of England. The stone was said to be cursed, and that could have been the cause of the very many misfortunes in Evalyn's life.

The first time Pierre Cartier tried to sell it to her, she didn't like the setting. He knew she adored fine jewels and would be one of the few willing to purchase such a lavish stone. So he shared with her the tale of its sordid past and made a new setting for the necklace. Intrigued by the curse and the loan of the jewel for a few days, she finally purchased it for $180,000. The diamond

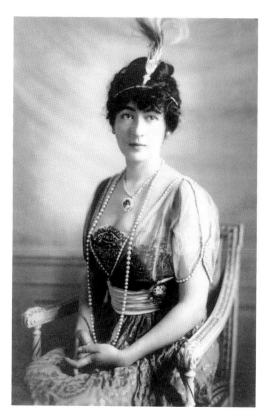

Evalyn Walsh McLean, jewels and all. *Library of Congress Prints and Photographs Collection.*

became her go-to piece while entertaining. Sometimes she would even wrap it around the neck of her dog as a dog collar to shock her guests.

The diamond was beautiful and legendary, two characteristics Evalyn loved. Despite the letters attesting to its curse, she believed that she was an exception. With each tragedy, the rumors would start again. Her beloved son was killed in an automobile accident. Ned left her for another woman and eventually left all his money to someone with whom he spent happier days. The *Washington Post* went bankrupt. Her daughter died of an overdose. A man pretending to need ransom money for the kidnapped Lindbergh baby swindled her out of $100,000.

Evalyn died of pneumonia in the 1940s as the last owner of the Hope Diamond. Perhaps no one else was brave enough to own it, and it is now on display at the Smithsonian Natural History Museum.

DALLYING DOLLS

Affairs were a part of life in the nineteenth century—as long as it was the men who were having them. Philandering husbands were common; women who stepped out on their men were not. Or perhaps they were simply not caught as often.

TEMPORARY INSANITY

Some, however, were caught. Teresa Bagioli Sickles's affair ruined her life and ended another.

Teresa Bagioli was a beautiful and intelligent young lady when she officially met Daniel Sickles. They had actually met before, but she was an infant at the time and he a college student. Sickles was living with Teresa's family while at New York University when he was first introduced to the Bagioli clan. Little did he know that the girl crawling at his feet while he was trying to study would become his wife. When he proposed marriage to fifteen-year-old Teresa, he was thirty-three years old.

Despite their long friendship, Teresa's family did not approve of the match. Sickles was a known womanizer and far older than his bride. Despite running a law practice in the city, he had some run-ins with the law himself. He was indicted, charged and accused multiple times of various shady ways of obtaining money, often through fraud. But as soon as you tell a teenager not to do something,

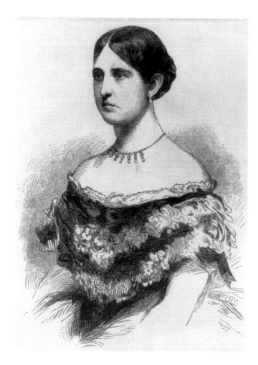

Teresa Bagioli Sickles, wife of Daniel Sickles and lover of Philip Barton Key. *Library of Congress Prints and Photographs Collection.*

it's the first thing she does. This also applied in the middle of the 1800s, and Teresa and Sickles wed in a civil ceremony.

This was one way to get what she wanted. The Catholic family did not want their daughter married in a courthouse by the mayor, so they relented and had an actual wedding ceremony officiated by the archbishop of New York. Shortly after—some might say a little too shortly—Teresa gave birth to their daughter. Perhaps that was another reason the real Catholic wedding went forward, despite her parents' wishes.

A few years later, his political career brought Sickles to Washington, where they purchased a house in Lafayette Square across from the White House. The two were fixtures in society, but Sickles's philandering ways had not succumbed to marital commitment. He was often away from his wife but still seen in the company of women. He had a penchant for prostitutes and is said to have brought a certain lady of the night into the New York Senate chambers and on a trip to England, when she was presented to the queen.

Teresa fulfilled the obligations of a rising political star's wife and attended numerous events and parties. Should her husband be away, it was not uncommon that a bachelor accompanied her. This was the standard of the day, and the most eligible bachelor in town was widower Philip Barton Key. His father was a Georgetown lawyer and a bit of a poet. Francis Scott Key's poem "In Defense of Fort McHenry" is rather well known today, but we call it the "Star-Spangled Banner."

Gossip started to spread that Key was doing more than just accompanying Teresa to parties. In fact, the two were having an affair and weren't especially stealthy about it. In the park across from Teresa's house, Key might walk past and wave his white handkerchief. Teresa would respond likewise, and the

Right: Philip Barton Key, son of Francis Scott Key, shot by Daniel Sickles. *Library of Congress Prints and Photographs Collection.*

Below: Drawing of Daniel Sickles shooting Philip Barton Key in Lafayette Square, in front of the White House. *Library of Congress Prints and Photographs Collection.*

two would meet in a rented house a few blocks away. If ever Teresa fancied a walk down Fifteenth Street by this house, she might notice a string hanging from the windowsill indicating that Key was in and open to her visit.

As the public caught on, an anonymous source relayed the affair to Sickles. Outraged, he confronted his wife and forced her to write a damning confession. She had to relate specific details of when, where and how the affair took place. Obviously, she had no chance to tell Key any of this. So when he stood in the park signaling to Teresa, Sickles saw. Storming out of the house and after Key, he confronted him and yelled that Key had dishonored his bed.

With the pistol he grabbed on the way out of his house, Sickles shot his wife's lover from a few feet away in broad daylight in front of the White House. Key died not long after, and Sickles only asked if the scoundrel was dead.

Sickles was arrested, as there were many witnesses, but the jury would find him not guilty. It is the first instance of using temporary insanity as a defense and winning. The newspapers and the public were all on Sickles's side. When it was relayed that he had forgiven his wife, the public was outraged, and it put an end to his political career. Sickles and his wife never properly reconciled or even lived together, but they never formally divorced either. She died a few years later, alone.

He may have been outraged at the brazen Key signaling for an affair under his very eyes, or he might have just been a slightly unbalanced person. With the outbreak of the Civil War, Sickles joined the army. A cannonball mangled his leg at the Battle of Gettysburg, forcing an amputation. Sickles had the remnants of his leg and the cannonball preserved and brought back to Washington, D.C., where he donated them to the Army Medical Museum. Every year on the anniversary of the amputation, he went to visit the leg. You can, too. It's still on display at the National Museum of Health and Medicine.

The Petticoat Affair

In 1831, the secretaries of the navy, treasury and state and the attorney general were all brought down by one woman, with whom they never even had affairs. In fact, they never even socialized with her, and that was the problem. It is said she was only called "Peggy" by her enemies, so in the interests of her wishes, we'll call her by her given name.

Margaret O'Neale was raised in a boardinghouse, working alongside her Irish father catering to politicians at the corner of Twenty-first and Pennsylvania Avenues Northwest. Regarded as vivacious, witty and attractive, Margaret was known to many of the congressmen and military men who resided at the boardinghouse. The

Margaret "Peggy" Eaton as depicted on a box of cigars sold by R.C. Company. *R.C. Company.*

wife of the chief magistrate crowned her the "most beautiful girl in the nation's capital," a title that would not be held for long—due to the public opinion, not any diminishing of her looks.

Stories of her promiscuity as a teenager abound. It is rumored that a young man committed suicide after she denied his advances. Another rumor spread that she had a dalliance with the son of one of President Jefferson's cabinet members. At one point, two men, Major Francis Smith Belton and Captain Root, were courting her for marriage. They dueled for her honor, and she ran off with one—which one, we aren't sure, as multiple reports name each. The young lovers did not make it far. Running along the roof to escape, she knocked a plant off the sill, awakening her father. To avoid scandal and to temper the spirit of his daughter, Mr. O'Neale sent her to New York.

Proof of her wit and her status as a daddy's girl, Margaret wrote to her father pleading to come home. In her note, she played on the name of one of her suitors: "Neither Root nor branch will tear me away from you." Needless to say, it worked, and she returned home.

Shortly after returning, at the age of seventeen, the beauty of the town was married to the tall, blond John Timberlake. He was more than twice her age and heavily in debt, but perhaps marriage would settle down the wild Margaret. Married with two young girls, the store the Timberlakes were running floundered, and he returned to the navy. Margaret continued to tend bar at her father's establishment, where she conversed with boarders Andrew Jackson and Senator John Henry Eaton.

Eaton knew both Margaret and her husband. Timberlake even asked Eaton to take care of his wife and daughters should anything happen to him. While her husband was away at sea, she was seen being a bit flirtatious with Eaton, her escort around town, leading many to assume an affair. The public

later thought their assumptions accurate when Eaton married Margaret only eight months after Timberlake died at sea. Some said Timberlake committed suicide, distraught when he learned of the affair, while others said that he did it to avoid prosecution for mishandling money as purser. Officially, he died of pulmonary disease.

Andrew Jackson, recently elected president, was a friend of both Margaret and John Henry Eaton. In fact, it was with Jackson's blessing that the two were married. Eaton's first wife was niece to Mrs. Jackson. Eaton asked Jackson his opinion on his marrying Margaret and received support. Jackson knew what rumors could do to the fragile spirit of a woman, believing that the stress of rumors had killed his beloved wife, Rachel, and pressed upon Eaton to honor Margaret, believing the rumors would stop. He was wrong, both about the end of the gossip and about the fragile spirit of a woman, especially Margaret.

Women of society never considered Margaret O'Neale Timberlake Eaton to be one of their own, and her marriage to a senator was not going to change that. As a widow, she never wore black and remarried in less than a year. She grew up in a boardinghouse as the daughter of an Irish tavern-keeper and thus did not have the manners expected of a senator's wife. The other wives did not talk to her at the inauguration.

Socialite Margaret Bayard Smith stated that Margaret Eaton "has never been admitted into good society, is very handsome and of not an inspiring character and violent temper. She is, it is said, irresistible and carries whatever point she sets her mind on." She was not the demure hostess and did not need a man to stand up for her.

A rumor had made its way to Jackson that Margaret had an abortion a year after Timberlake had left for the navy, suggesting an affair. When she heard this, Margaret took the matter into her own hands. The story was traced back to Reverend Ezra Ely in Philadelphia, so she went to Philadelphia and subjected Ely to a six-hour interrogation, possibly with violence toward him, until he confessed his source. It was John N. Campbell, a previous chaplain of the House of Representatives and pastor at the Second Presbyterian Church, who had shared these views with Reverend Ely. When Margaret found him, she intimidated him into confessing. A meeting with Andrew Jackson to clear up the matter resulted in the resignation of Campbell and his moving to New York.

That was the first, but not the last, resignation caused by Margaret. Vice President John C. Calhoun and Secretary of State Martin Van Buren both wanted to be Jackson's successor. It was Margaret who decided their fates.

Hoping to quell the gossip about an affair, Jackson named Eaton as secretary of war. That did not work. Jackson was counseled against it, to which he responded, "Do you suppose that I have been sent here by the people to consult the ladies of Washington as to the proper persons to compose my cabinet?" Calhoun's wife, Floride, set the stage for how the society women would accept Margaret into the circle—they wouldn't. When Margaret called on Floride, the second lady did not return the favor, and thus no other woman of class would, either. The wives visibly snubbed Mrs. Eaton. The inaugural party thrown by the president was over in hours as guests quickly made their way through the evening to avoid the Eatons. The party thrown by Van Buren had a severe lack of wives, as they all conveniently had prior obligations that night. At a party thrown by Baron Krudner, the wife of the Dutch minister Huygens was seated next to Margaret. Rather than accept a slap to her social standing, Mrs. Huygens left the ball. When the president found out about this, he threatened to have both the minister and his wife sent back to the Netherlands.

Without a wife in the White House, Andrew Jackson's niece Emily Donelson acted as the official hostess. She, too, did not accept Margaret. For this, Jackson dismissed her and sent her back to Tennessee because she refused to get along. Secretary of the Treasury Samuel Ingham, Attorney General John Berrien and Secretary of the Navy John Branch could not convince their wives to behave, if they even tried. The two members of the cabinet to remain on the good side of Andrew Jackson were the widowed Martin Van Buren, secretary of state, and William T. Barry, postmaster general. Margaret helped nurse Barry's ill child.

In the spring of 1831, five of the six cabinet members resigned over this so-called Eaton Malaria. The political mind of Van Buren knew that Jackson would never ask Eaton to resign, even though it was quarrels over his wife that caused dissention in the cabinet. Selflessly, Van Buren and Eaton offered their resignation as secretary of state and secretary of war, respectively, sparing Jackson the trouble. Following suit, Branch, Ingham, Berrien and Calhoun were all asked to leave—both on account of their wives and because of political differences.

These acts led to the political ascendency of Martin Van Buren, who would later become president. It squashed the goals of Calhoun, however. Though he was later elected senator, he would not return to the White House. Fallen into relative obscurity, history does not remember much of Berrien, Branch or Ingham, though the story goes that after insulting Margaret, Ingham was challenged to a duel by Eaton. When that was refused, Eaton, determined

to have his revenge, stalked the former secretary of treasury until he snuck out of the city in the dead of night. Postmaster General Barry was the only member of the cabinet to remain in his post.

Continuing her effect on Washington politics, when the *Telegraph* newspaper called Margaret "Mrs. Pompadour the Second," Jackson had an additional publication created to defend her. Madame Pompadour was the official mistress to the king of France in the eighteenth century, so this offended both Margaret and President Jackson. The *Telegraph* was the original organ of the Jackson administration until it insulted Margaret and backed Calhoun. To compete, Jackson revoked the patronage of the *Telegraph* and named Francis Preston Blair editor of the *Globe*, using that to support the administration. Blair, an ardent Jackson supporter, would go on to influence future presidents. The official guesthouse for visiting heads of state, the Blair House, was his residence.

Jackson named new members to his cabinet, and the Eatons moved to Florida and then to Spain on state business. In Europe, unlike in the States, Margaret was a social favorite. Her daughter, Virginia, married Duke De Sampayo of Paris, and her granddaughter became Baroness de Rothschild of Austria. Margaret, however, would return to D.C. and continue making socially questionable decisions. John Eaton accompanied her back to Washington, D.C., where he died in 1856.

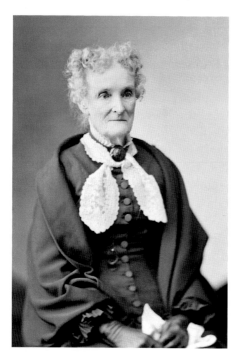

Margaret Eaton as an older woman. *Library of Congress Prints and Photographs Collection.*

After John Eaton's death, Margaret married her granddaughter's dance teacher, Antonio Buchignani, who was nineteen to her fifty-nine. Though she aged well, he, not unexpectedly, ran off with her granddaughter and all her money. Margaret died in a home for destitute women and is buried alongside her second husband, Eaton, in Oak Hill Cemetery.

Ever the independent woman, Margaret did not apologize for her actions. Of the women who

snubbed her, she said, "I was quite as independent as they, and had more powerful friends…None of them had beauty, accomplishments or graces in society of any kind, and for these reasons…they were jealous of me."

And while her legacy remains best known under the lighthearted name of the "Petticoat Affair," one of the many things Margaret left us with was a toast: "To the next cabinet, may they all be bachelors or leave their wives at home."

She Could Have Been a Princess

Many young girls dream of being princesses. Many young women dream of finding a love so strong that the prince would leave his throne for her. Though this happened to Grace Kelly and Wallis Simpson, it wouldn't be so for young Katherine Elkins, who had a much-gossiped-about relationship with the Duke of Abruzzi.

Born in the Royal Palace of Madrid in 1873 to the House of Savoy, Prince Luigi Amedeo Giuseppe Maria Ferdinando Francesco of Savoy-Aosta was the infante of Spain, later to become the Duke of Abruzzi. For the sake of brevity, we'll just call him the Duke. He was the grandson of the King of Italy and son to the (at the time) king of Spain in a royal family that could trace its noble lineage to the twelfth century.

As a young man, the Duke took to mountaineering. He climbed Alaskan glaciers, Ugandan peaks and Pakistani mountains, but his most well-known exploit is the expedition to the North Pole. Though he set a record in 1899, he never quite made it and lost two fingers in the process. During World War I, he was vice-admiral of the Italian Adriatic fleet, and he single-handedly saved the entire Serbian army. Obviously, this isn't true, but to glance at the Duke's proud stature, faraway gaze and the regalia adorning his uniform, he seems the kind of man one would easy believe could single-handedly save an army.

What was lacking from his remarkable life was a love interest. Fitting for this adventurer, he fell into a scandalous romance with an American. Katherine "Kitty" Hallie Elkins was the daughter of politician Stephen Benton Elkins and Hallie Davis Elkins.

The contemporary rumors of their first meeting are conflicted, but most reports agree it was in Florida in 1907, on his third visit to America, when the Duke met young Kitty. When the Elkinses left for Baltimore, the Duke accompanied them.

The Italian Duke of Abruzzi, who never won the love of his life. *Library of Congress Prints and Photographs Collection.*

The engagement of Kitty Elkins to the Duke of Abruzzi was announced unofficially in the newspapers in 1909. The Duke had secretly been courting her for the two years prior, and with the announcement, the gossip, rumors and speculation began. European royalty came out in favor or against the marriage of royalty to a commoner. Kitty herself claimed there was no engagement, and her father simply stated it was none of the public's business. Being told not to pay attention to the affair only made the public hunger for more.

Newspapers from November 1910 speculate as to the whereabouts of Kitty. Some claimed she was in Lugarno converting to Catholicism to prepare for the marriage to the Duke, while others said she was in Washington caring for her ailing father. The American public loved a lover and still believed Kitty was to be named Duchess of Teramo and that the King of Italy had given his consent to the marriage.

Italians were in an uproar that the Duke would marry a commoner. Since the Duke remained committed to the planned marriage, claiming it would continue with or without consent from his cousin the king, white paint was prepared for a fresh coat on Italian battleships to escort the Duke and Duchess to be back to Naples for their honeymoon. A wedding cake was designed and said to be a "one-thousand pound affair," and the tiara meant for Kitty's head was worth $120,000.

The Duke refused royal marriage proposals to the princesses of Russia, Romania and Connaught because of his love of Kitty. For five faithful years, he courted her and went against the wishes of his family and country. The most ardent opposition of the Duke's marriage to "this daughter of a coal dealer" came from his sister-in-law, the Duchess Helene of Aosta. The Dowager Queen Margharita was initially against the marriage, and

while she never gave consent, she eventually decided not to interfere. To the people of Italy, Kitty was simply known as "the foreigner."

For five years, international travel and cables went back and forth between the parents and children to find approval for this love affair. At first, Senator Elkins gave his consent, but when the Italian court said it would not recognize Kitty as a duchess beyond the title, Elkins refused. At one point, it was suggested that the Duke give up his title and move to America to live off the Elkinses' wealth and connections.

In those five years, Kitty had another suitor. William Hitt of Washington was the preferred choice to Kitty's father, who wanted an American son-in-law. With the encouragement of Senator Elkins and Kitty's brother, Hitt continued his courtship of the young girl. Despite an engagement announcement and wedding date for her union with the Duke, Hitt continued to patiently wait and declare his intentions.

Although the Italians wanted nothing to do with "the foreigner," a bigger insult to their pride would have been for the foreigner to choose a commoner over an Italian duke. When an unfounded rumor spread that Hitt and Elkins had married, it was said that Hitt was in Rome. The Romans searched local hotels trying to find him in order to challenge him to a duel.

Hitt said he would serve Kitty for seven years and then she must decide. He knew, or hoped, that the Duke and his love would never be permitted to marry. In November 1913, the triangular love affair had the world waiting to see who Kitty would choose.

In Paris, Kitty was seen in the continued presence of Billy Hitt, who returned aboard the same steamship as the Elkinses to the States. Through the years, the engagement of Kitty Elkins to the Duke of Abruzzi was always imminent and surely to happen next month—when the King consented, or maybe the following month when the Duke returned from the Himalayas. Despite the public's desire for a happy ending for the Duke, all rumors of the pending engagement were quashed when Kitty and Billy wed on October 27, 1913.

It was an informal and spontaneous affair. With no thousand-dollar tiara or thousand-pound wedding cake, Mrs. Hitt only learned of her son's marriage by telegram, and Mrs. Elkins got the news only a few hours prior to the ceremony.

In the end, Billy was the wrong choice. The couple found that they were not compatible as lovers but merely as friends, and Kitty quietly filed for divorce in France, as was common at the time. They both remained in Washington, D.C., and frequently met at social events and parties.

Kitty Elkins at a horse show after her marriage to William Hitt. *Library of Congress Prints and Photographs Collection.*

In 1920, after not hearing from the Duke for some time, the American people found renewed interested in this love, or rather love lost, story. The Duke was leaving the palaces of Venice to live in Somalia. What other reason could he have but the continued disappointment from losing his one true love? It is said that he claimed if he could not marry Kitty, he would never marry. In the end, however, he married a young Somalian woman, Faduma Ali, having given up worrying about the consent of his family.

The Duke died in 1933 in Somalia, and whether it was significant or purely coincidental in timing, Kitty and Billy remarried that same year and remained so until her death three years later. Katherine Elkins Hitt is buried in Rock Creek Cemetery in Washington, D.C.

Judo for Women

In 1904, Japanese judo instructor Yoshitsugu (Yoshiaki) Yamashita came to D.C. to calm the undisciplined ways of the young son of socialite Mary Hill Hill. Mary had married a man whose surname was also Hill, and she insisted on using both. The Hills paid the way for Yamashita to come to the United States, where he is credited with introducing judo to Americans. However, upon his arrival in D.C., Yamashita never made it to the Hill Hill residence and instead was recruited by President Teddy Roosevelt. Roosevelt used these lessons in press coverage for his reelection, lining the White House basement with mats and even practicing with his wife. Teddy Roosevelt was America's first brown belt.

While these judo lessons may have impressed some, they encouraged others—namely, Martha Blow Wadsworth, who sought to diminish the public opinion of Roosevelt's exploits by repeating them herself. She had already beat a record set by the president by riding sidesaddle in relays for 212 miles in fifteen hours just to spite him, so of course, when she heard of the president's judo training, she recruited Yamashita's wife, Fude, to begin a women's judo class. Among the students were Hallie and her daughter Katherine Elkins.

Pretty Katie

Not royalty technically but queen hostess in Civil War Washington, young red-haired beauty Kate Chase ruled the social scene. Kate had grace, education, beauty and, most of all, ambition. As the most treasured daughter to future secretary of the treasury Salmon Chase, Kate masterminded his political campaign. With the goal of making her father president and keeping him from remarrying, Kate schemed to become first lady, the official hostess of the city.

Kate's mother had died when she was only five years old. The precocious tot did not fare well under the guidance of her new stepmother, who was ill with tuberculosis and trying to care for her own newborn, and she was sent off to boarding school at the tender age of nine. At school, Kate was educated in science, languages, elocution and the graces needed for society life. When she and her father agreed that she was finished with a formal education, Kate returned to Ohio at the age of nineteen to aid her widowed (for the third time) father, the governor of Ohio.

Governor Chase purchased a house in Columbus and instructed Kate on the smallest of details on how to set it up. This would now be the full-time residence of the young woman. During their time in Ohio, Kate and her father grew close while attending social functions. As she attended finishing school to perfect her skills as a lady, Kate was also sharpening her political abilities. With ascendency of her father in the nascent Republican Party, Kate was becoming an essential aid to her father's political career.

Unfortunately for Kate, it would be a long road. Her father lacked an important skill of nineteenth-century politicking: he wasn't an inspiring speaker. While it helped him earn a Senate seat for Ohio, his passionate antislavery stance would keep him from the presidential nomination for the Republican Party in the 1860 election. Instead, Chase gave his support to Abraham Lincoln and was later named secretary of the treasury. Chase moved to Sixth and E Streets Northwest in Washington, D.C. With him came Kate.

As the eldest daughter of a widowed cabinet member, Kate had a standing in society by default. Add to that the reclusive nature of Secretary of State Seward's wife and the state of sorrow Mary Todd Lincoln would soon find herself in, and Kate Chase was outranked by none in the social scene. The tragic loss of her son, Willie, kept Mary Lincoln from the public. As first lady, she would have been superior on the social ladder if she were not consumed by grief. Rightly so, Mary considered the younger and more attractive Kate a rival, even forbidding President Lincoln to dance with Kate.

Kate was a two-part threat, for she had political knowledge but also the charming ways of a beautiful woman. Newspapers called her the "dictator of fashion." Society lady Isabella Trotter described Kate as "tall and slight, but at the same time beautifully rounded; her neck long and graceful, with a sweet pretty brunette face. I have seldom seen such lovely eyes and dark eyelashes." Rather than adorn herself with jewels, she inspired a floral style and wore lilies and pansies in her hair and on her clothes. She had a certain effect on the men in the city. Lincoln's secretary, John Hay, wrote in a letter to his friend about his dismay when it was not he who won the hand of the girl he called "Pretty Katie." He wrote, "Miss Chase is so busy making her father next President that she is only a little lovelier than all other women. She is to be married on November 12th, which disgusts me with life. She is a great woman with a great future."

With the admiration of men in power and the political persuasion of an intelligent woman, Kate inspired a fear of being replaced in Mary Lincoln. Mary's woman's intuition was right because Kate was aiming for her position. With Kate's behind-the-scenes maneuvering, Chase aimed for the Republican

nomination in 1864, the Democratic nomination in 1868 and the Liberal Republican nomination in 1872. None of the three parties he offered himself to ever nominated him, despite his daughter's efforts.

Salmon Chase had a successful political career, even if it did not reach the highest office he and his family aimed for. If you've ever seen one, he is depicted on the $10,000 bill. It was Chase who is credited with the modern national banking system and paper banknote created under Lincoln during the Civil War to standardize and stabilize currency.

Kate's political goals were more important than her social standing, which was more important than her marriage. In November 1863, Kate married Rhode Island senator

A young Kate Chase. *Library of Congress Prints and Photographs Collection.*

William Sprague. He was infatuated with her, saying, "The business which takes my time, my attention, my heart, my all, is of a certain young lady who has become so entwined in every pulsation, that my former self lost its identity."

Kate, however, may have been fonder of his wallet than of him. Her expensive tastes were not supported by her father's salary in Washington and nearly brought him to financial ruin. After her marriage, she continued her extravagant spending, much to the dismay of her husband. The opulent life of the couple started off with a wedding gift of a $50,000 pearl-and-diamond tiara for the bride. The U.S. Marine Band performed a piece written especially for the wedding, "The Kate Chase March." As the social event of the season, the wedding guest list was a who's who of Washington, including the president, though not his wife. The Sprague house was decorated with Persian bowls made of garnets for the Shah

and a tapestry once owned by Marie Antoinette. Newspapers commented that Kate's expensive fashion "made the Astors look like fishwomen."

As with many marriages founded out of lust for power, money and beauty, this one did not end well. Kate placed her father's political ambitions above her husband, while Sprague put more effort into his poor business practices and his drinking. Finding love in all the wrong places, Kate turned to Roscoe Conkling, a New York Republican congressman and known womanizer. Kate was seen about town accompanied by him at social events and appearing in the Senate gallery while he was on the floor.

Sprague accused Conkling of having an affair with his wife and warned him not to appear in his presence again. When Conkling did, staying as an overnight guest in the Spragues' Rhode Island home while on business, or so Kate said, Sprague chased him out with a shotgun, most likely while drunk. Sprague followed Conkling into town to make sure he was truly leaving.

The veracity of the affair is up for debate, but Kate did use Conkling's friendship in at least one instance. They say to beware a woman scorned, but perhaps it should be amended to warn against coming between a woman and her political ambitions. At the 1864 Democratic Convention, in which her father was running for the nomination for president, the ticket was snatched away from them by Samuel Tilden in favor of Horatio Seymour. Kate never forgave nor forgot. In the 1876 election, Tilden himself ran for president on the Democratic ticket against Republican candidate Rutherford B. Hayes. Technically, Tilden won, as he had the most popular votes. American politics does not work on technicalities, however, and our presidents aren't chosen by popular vote. Due to an issue with the electoral votes from some states, the election ended up in the hands of a special Senatorial committee. On this committee was Rosco Conkling, the friend and/or lover of this woman scorned. Kate is said to have persuaded Conkling to vote against Tilden, handing the presidency to Hayes and ending Tilden's political career. Revenge at last.

After her divorce from Sprague, Kate resumed using her maiden name and retired to her father's estate at the edge of the city in Edgewood. The estate was mortgaged, and Kate could not indulge in her wealthy ways. The women who used to envy her station in life paid for vegetables from the estate's garden to support the dethroned queen of society. Kate Chase died a broken and broke woman.

Anti-Flirt Club

While there were a number of women in nineteenth-century Washington who reveled in the attention of men, as the city entered the twentieth century, there was a change among the young ladies of the District. Not all of the women in Washington, D.C., enjoyed these flirtations. In fact, they now organized against them.

The Anti-Flirt Club was created in 1923 by a group of young ladies who were tired of the horns honking and catcalls from passing vehicles. March 4, 1923, marked the beginning of the first—well, the only—Anti-Flirt Week in the city.

D.C.'s Anti-Flirt Club was specific in its targeting of vehicular flirtations. Men would call to women on street corners, offering rides to save the girls the walk. This drive-by flirting was not at all altruistic, and these women believed that most men had ulterior motives. And, let's be honest, most of them probably did.

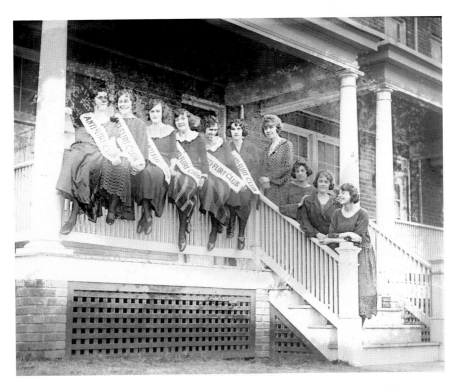

The Washington, D.C. Anti-Flirt Club. *Library of Congress Prints and Photographs Collection.*

The club had its own ten commandments to be followed:

1. *Don't flirt; those who flirt in haste oft repent in leisure.*
2. *Don't accept rides from flirting motorists—they don't all invite you in to save you a walk.*
3. *Don't use your eyes for ogling—they were made for worthier purposes.*
4. *Don't go out with men you don't know—they may be married, and you may be in for a hair-pulling match.*
5. *Don't wink—a flutter of one eye may cause a tear in the other.*
6. *Don't smile at flirtatious strangers—save them for people you know.*
7. *Don't annex all the men you can get—by flirting with many you may lose out on the one.*
8. *Don't fall for the slick, dandified cake eater—the unpolished gold of a real man is worth more than the gloss of lounge lizard.*
9. *Don't let elderly men with an eye to a flirtation pat you on the shoulder and take a fatherly interest in you. Those are usually the kind who wants to forget they are fathers.*
10. *Don't ignore the man you are sure of while you flirt with another. When you return to the first one you may find him gone.*

So maybe not every woman in Washington, D.C., was all that wild…

BIBLIOGRAPHY

Adams, Katherine H., and Michael L. Keene. *Alice Paul and the American Suffrage Campaign*. Urbana: University of Illinois Press, 2008.

Allgor, Catherine. *A Perfect Union: Dolley Madison and the Creation of the American Nation*. New York: Henry Holt & Company, 2006.

Anthony, Carl Sferrazza. *Florence Harding: The First Lady, the Jazz Age, and the Death of America's Most Scandalous President*. New York: W. Morrow & Company, 1998.

Association for the Preservation of the Historic Congressional Cemetery. "Obituary of Mary Ann Hall." http://www.congressionalcemetery.org/obituary-hall-mary-ann.

Beeckman, Margaret Gardiner. *Leaves from a Young Girl's Diary: The Journal of Margaret Gardiner, 1840*. New Haven, CT: Tuttle, Morehouse & Taylor Company, 1925.

Biggers, Jeff. "Meet Anne Royall: The Muckraker Who Made Washington Bow Down in Fear." *Huffington Post*, December 4, 2013. http://www.huffingtonpost.com/jeff-biggers/meet-anne-royall-the-muck_b_4381394.html.

Clemmer, Mary. *Ten Years in Washington: Life and Scenes in the National Capital, as a Woman Sees Them.* Hartford, CT: A.D. Worthington & Co., 1874.

Cordery, Stacy A. *Alice: Alice Roosevelt Longworth, from White House Princess to Washington Power Broker.* New York: Viking, 2007.

Fields, Joseph E., ed. *Worthy Partner: The Papers of Martha Washington.* Westport, CT: Greenwood Press, 1994.

Greenhow, Rose. *My Imprisonment and the First Year of Abolition Rule at Washington.* London: R. Bentley, 1863.

Hamilton, James A. *Reminiscences of James A. Hamilton; or, Men and Events, at Home and Abroad, During Three Quarters of a Century.* New York: C. Scribner & Co., 1869.

Harvey, Sheridan. "Marching for the Vote: Remembering the Woman Suffrage Parade of 1913." http://memory.loc.gov/ammem/awhhtml/aw01e/aw01e.html.

Hay, John. *At Lincoln's Side: John Hay's Civil War Correspondence and Selected Writings.* Edited by Michael Burlingame. Carbondale: Southern Illinois University Press, 2000.

Johnston, Francis B. "What a Woman Can Do with a Camera." *Ladies' Home Journal,* 1897.

Keckley, Elizabeth. *Behind the Scenes: or, Thirty Years a Slave and Four Years in the White House.* New York: Oxford University Press, 1988.

King, Willard L. *Lincoln's Manager, David Davis.* Cambridge, MA: Harvard University Press, 1960.

The Lincoln Institute. "Mr. Lincoln's White House." http://www.mrlincolnswhitehouse.org.

Lincoln, William Sever. *Life with the Thirty-Fourth Mass. Infantry in the War of the Rebellion.* Bethesda, MD: University Publications of America, 1991.

Lovell, Mary S. *Cast No Shadow: The Life of the American Spy Who Changed the Course of World War II.* New York: Pantheon Books, 1992.

"Mary Foote Henderson: The Iron-Willed Empress of Meridian Hill." Streets of Washington. http://www.streetsofwashington.com/2011/07/iron-willed-empress-of-meridian-hill.html.

Mays, Joe H. *Black Americans and Their Contributions toward Union Victory in the American Civil War, 1861–1865.* Bethesda, MD: University Press of America, 1984.

McIntosh, Elizabeth P. *Sisterhood of Spies: The Women of the OSS.* Annapolis, MD: Naval Institute Press, 1998.

McLean, Evalyn W. *Queen of Diamonds: The Fabled Legacy of Evalyn Walsh McLean.* CMV ed. Turner (e-book), 2005. Franklin, TN: Hillsboro Press, Providence House Publishers, n.d.

McLean, Evalyn Walsh, and Boyden Sparkes. *Father Struck It Rich.* Boston: Little, Brown and Company, 1936.

Museum of Modern Art. "The Hampton Album." News release, New York, 1965.

National First Ladies' Library. http://www.firstladies.org/.

National Parks Service. "Clara Barton and Andersonville." http://www.nps.gov/ande/historyculture/clara_barton.htm.

Oates, Stephen B. *A Woman of Valor: Clara Barton and the Civil War.* New York: Free Press, 1994.

Parton, James. *People's Book of Biography; or, Short Lives of the Most Interesting Persons of All Ages and Countries.* Hartford, CT: A.S. Hale, 1869.

Poore, Benjamin Perley. *Perley's Reminiscences of Sixty Years in the National Metropolis.* Philadelphia: Hubbard Bros., 1886.

Rhodes, Jane. *Mary Ann Shadd Cary: The Black Press and Protest in the Nineteenth Century.* Bloomington: Indiana University Press, 1998.

Roosevelt, Eleanor, and Lorena A. Hickok. *Empty Without You: The Intimate Letters of Eleanor Roosevelt and Lorena Hickok.* Edited by Rodger Streitmatter. New York: Free Press, 1998.

Russell, William Howard. *William Howard Russell's Civil War: Private Diary and Letters, 1861–1862.* Edited by Martin Crawford. Athens: University of Georgia Press, 1992.

Safranski, Debby Burnett. *Angel of Andersonville, Prince of Tahiti: The Extraordinary Life of Dorence Atwater.* Holland, MO: Alling-Porterfield Publishing House, 2008.

Smith, Margaret, and Gaillard Hunt. *The First Forty Years of Washington Society.* New York: Scribner, 1906.

Smithsonian—Architectural History and Historic Preservation Department. "Madam on the Mall." http://www.si.edu/ahhp/madam.

(Staunton, VA) Spectator. "Sent South." July 21, 1863.

Stuart, Nancy Rubin. *American Empress: The Life and Times of Marjorie Merriweather Post.* New York: Villard Books, 1995.

Terborg-Penn, Rosalyn. *African American Women in the Struggle for the Vote, 1850–1920.* Bloomington: Indiana University Press, 1998.

Truth's Advocate and Monthly Anti-Jackson Expositor. Cincinnati: Lodge, L'Hommedieu, and Hammond, 1828.

"(UCCL 01136)." Samuel L. Clemens to Henry Watterson. October 9, 1874. Hartford, CT.

Vedder, Sarah E. *Reminiscences of the District of Columbia; or, Washington City Seventy-nine Years Ago, 1830–1909.* St. Louis, MO: Press A.R. Fleming Print, 1909.

Wakeman, Sarah Rosetta. *An Uncommon Soldier: The Civil War Letters of Sarah Rosetta Wakeman, Alias Private Lyons Wakeman, 153rd Regiment, New York State Volunteers*. Edited by Lauren M. Cook. Pasadena, MD: Minerva Center, 1994.

Walker, Dale L. *Mary Edwards Walker: Above and Beyond*. New York: Forge, 2005.

Whitton, Mary Ormsbee. *First First Ladies*. New York: Hastings House, 1948.

ABOUT THE AUTHOR

C anden Schwantes is a historian and tour guide in Washington, D.C., and manages Free Tours by Foot, an international walking tour company. When she isn't showing tourists and locals around her favorite neighborhoods, Canden volunteers at the Historical Society of Washington, D.C. With a BA from Elon University and a master's from University College London, both in history, researching (and talking about) the stories of our past continues to be a favorite pastime. This is her second book with The History Press. *Wicked Georgetown: Scoundrels, Sinners and Spies* focuses on the darker side of the history of Georgetown neighborhoods. Canden has a penchant for historical fiction, off-trail hiking, traveling to new locales and listening to her fiancé, Manny Arciniega, in any of his musical endeavors.